IMAGINABLE W✴RLDS

Art, Crisis, and Global Futures

DIRECTORS' NOTE 1
ACKNOWLEDGEMENTS 3

INTRODUCTION: IMAGINABLE WORLDS

ORIANNA CACCHIONE, NANDITA JAISHANKAR & ARUSHI VATS 6

PRACTICE

PESSIMISTIC FUTURES: BLACK WORLDING THROUGH GAMES

PATRICK JAGODA & ASHLYN SPARROW 12

ASSEMBLING IN ISOLATION: THE POLITICS OF VIRTUAL PERFORMANCE IN AMITESH GROVER'S *THE LAST POET*

TRINA NILEENA BANERJEE & AMITESH GROVER 28

DALIT ART

SURAJ YENGDE 50

TOUCH

HOW TO LEAVE A HUSBAND

JEET THAYIL 64

WE ARE SAFE LETICIA BERNAUS 71

TEXTS FROM THE
END OF THE WORLD SIYANDA MOHUTSIWA 87

STRUCTURE

SIGNS OF THE TIMES UZODINMA IWEALA 106

H FOR HUMIDITY: KEYWORDS AND
NOTES ON INFRASTRUCTURES,
WATER, AND WATER ENGINEERING
IN SINGAPORE HO TZU NYEN 128

ALL WOMEN ARE WORKERS,
NOT ALL WORK IS WAGED:
THREE TALES OF SURVIVING
THE PANDEMIC IN PUDUCHERRY

MEENA KANDASAMY 150

AUTHOR BIOGRAPHIES 160

DIRECTORS' NOTE

Imaginable Worlds: Art, Crisis, and Global Futures grew from a shared intent between the Serendipity Arts Foundation, New Delhi, and the University of Chicago's Smart Museum of Art to collaborate across time zones, territorial limits, and contingencies in order to deepen the textures of our collective life. Activating the distinct institutional genealogies of an arts foundation and an academic art museum, during the early days of the COVID-19 pandemic, we stitched together diverse contributions to create an object of care, assembled over many seasons. This resulting publication presents writing and ideas in varied formats, using the conventions of essays, interviews, fiction, narrative journalism, photo essays, and glossaries. Voices from around the planet speak in proximity and solidarity, as prompts toward other imaginable futures that remain undetermined.

In 2017, Serendipity Arts Foundation took the first step toward building a research infrastructure to document, expand on, and critique the conventions and approaches that have shaped curatorial projects at the Serendipity Arts Festival. This initiative assumed the format of an annual publication series titled Projects/Processes that commissioned researchers to visit and experience shortlisted projects at the festival and develop their encounters into semi-academic essays that situated the project within the macro-histories of form and tradition in the subcontinent. With the onset of COVID-19, this model of physical immersion required a significant revision, and we amended our framework to accommodate autonomous and interconnected writing and research on urgent and necessary questions that confront us.

The publications program at the Smart Museum dates back to the beginnings of the museum's exhibitions program in 1974. Historically focusing on exhibition catalogues, Smart Museum publications bring together multiple contributors and perspectives, including scholars from the University of

Chicago community and across the globe, in order to open a space for and expand on new modes of thinking about art. These publications are sites of critical reflection, knowledge production, and, of course, rigorous inquiry. Though *Imaginable Worlds* departs from the traditional exhibition catalogue, the collaboration is a natural outgrowth of the program and retains the intellectual depth, creativity, and interdisciplinary nature for which the University of Chicago is known.

We are pleased to have made this connection between colleagues who were open to sharing ideas and developing this joint publication and look forward to more such collaborative projects. We are immensely grateful to UChicago Global for its generous and ongoing support. Without the connections fostered by the University of Chicago's Center in Delhi and its exceptional team led by Faculty Director Dipesh Chakrabarty, former Executive Director Aditi Mody, and current Executive Director Leni Chaudhuri, this project would not have been possible.

Together, our editors, Nandita Jaishankar, Senior Manager of Editorial & Programmes at Serendipity Arts Foundation, Orianna Cacchione, Curator of Global Contemporary Art at the Smart Museum, and Arushi Vats, former Editorial Manager at Serendipity Arts Foundation assembled contributors from far beyond our own communities.. We are extremely grateful for your creative thinking and care in guiding this project. We are indebted to the authors and artists who contributed to the volume and who reimagined crisis as a site of possibility, creation, and resistance. We are thrilled to be publishing new works by Trina Nileena Banerjee, Leticia Bernaus, Ho Tzu Nyen, Uzodinma Iweala, Patrick Jagoda, Meena Kandasamy, Siyunda Mohutsiwa, Ashlyn Sparrow, Jeet Thayil, and Suraj Yengde. Finally, we must acknowledge the collective efforts of the staff of Serendipity Arts and the Smart Museum for making this volume's publication possible, with special thanks to Gail Ana Gomez, the Smart's Associate Director of Exhibitions and Publications, for so effectively managing this volume and carefully overseeing it from its earliest moment of inception to its final publication.

Smriti Rajgarhia
Director
Serendipity Arts Foundation, New Delhi

Vanja Malloy
Dana Feitler Director
Smart Museum of Art, The University of Chicago

ACKNOWLEDGEMENTS

The onset of the COVID-19 pandemic and the rise of social distancing mandates over the past two years have made us reconsider the ways we interact with each other. The ongoing pandemic has challenged us to imagine new ways to envision work times and flows, spaces, processes, communications, and dynamics, and has been a unique opportunity to think creatively about how we engage with projects, such as book production. *Imaginable Worlds: Art, Crisis, and Global Futures* approaches the current pandemic as a research field to constructively imagine potential futures beyond the current global crisis, and indeed the very inception and production of this book is the outcome of it. *Imaginable Worlds* has been a truly collaborative project since the beginning for all the parties involved at the Serendipity Arts Foundation, New Delhi, the Smart Museum of Art at the University of Chicago, and the contributors from around the world. We want to extend our gratitude to everyone who participated, in one way or another, for their dedication, the countless hours spent on Zoom, and the multiple virtual exchanges that made this book possible.

Bringing together artists, public figures, and scholars from such diverse backgrounds, trajectories, and locations was not an easy endeavor, especially under the current circumstances. For their keen cooperation, we are especially grateful to our contributors who accepted the invitation to embark on this project: Trina Nileena Banerjee, Leticia Bernaus, Ho Tzu Nyen, Uzodinma Iweala, Patrick Jagoda, Meena Kandasamy, Siyanda Mohutsiwa, Ashlyn Sparrow, Jeet Thayil, and Suraj Yengde. A special thank you to the Dalit artists who kindly permitted us to feature their artwork in Suraj Yengde's essay on Dalit Art and share this unique art tradition with the broader public: Manish

Harijan, Prabhakar Kamble, Malvika Raj, Rajyashri Goody, Ranjeeta Kumari, Sajan Mani, Tejswani Narayan Sonawane, and Vikrant Bhise. We are also grateful to Amitesh Grover for spending a substantial amount of time discussing his cyber theater project, *The Last Poet*, with Trina Nileena Banerjee.

We are greatly indebted to Aditi Mody, former Executive Director at the University of Chicago Center in Delhi, for having initiated this fruitful dialogue between the Smart Museum and the Serendipity Arts Foundation. We are grateful to the University of Chicago Center in Delhi for the extraordinary generosity we have received, and in particular to Leni Chaudhuri, the current Executive Director, and Dipesh Chakrabarty, the Center's Faculty Director, for being so encouraging of the project. We also recognize the support of Suman Singh and Arvind Balyan at the Center in Delhi. This publication would not have been possible without the unfailing support of UChicago Global, especially Marie Bejarano and Steven Yandell. At the Smart Museum, we want to thank William J. Michel and Amina Dickerson, former Co-Interim Directors, for their commitment to this groundbreaking volume, and Stephanie Smith, the museum's current Interim Director, for championing the project to its completion. At Serendipity Arts Foundation, we extend our deepest gratitude to Smriti Rajgarhia, Director, for her enthusiasm and confidence in the project.

This volume would not have been possible without the unwavering commitment, collaboration, and diligent work of colleagues at the Smart Museum and Serendipity Arts Foundation. We have been honored and humbled by their contributions to this volume. We are exceedingly grateful to Gail Ana Gomez, the Smart Museum's Associate Director of Exhibitions and Publications, who shared her expertise with us and oversaw the development of this project from its inception to its culmination. We owe a particular debt of gratitude to Simone Levine, former Curatorial Research Assistant for Global Contemporary Art, for her assistance during the very early stages of the project, and to Shane Rothe, current Curatorial Research Assistant, for their support at the latest stage. We also want to recognize the enormous role Norman Mora Quintero, the Smart's Editorial Intern, played in assisting with editorial and administrative management during the last year. At the University of Chicago Press, we want to thank Carrie Olivia Adams, Promotions Director, for guiding us through the promotion and publication process. Natalie Haddad's sensitivity to language, astute eye, and careful editing provided an essential role in finalizing all of the texts and bringing clarity of form and voice to each. And lastly, Sukanya Baskar brought innovation and futuristic thinking to the design of this volume. We are grateful for her creativity and vision,

which helped bring so many diverse contributions together. We have worked through incredible circumstances for the last two years. *Imaginable Worlds* would not have been possible without any of you. We hope that the bridge built between the Smart Museum and the Serendipity Arts Foundation continues to foster creative projects and new global futures.

Orianna Cacchione
Curator of Global Contemporary Art
Smart Museum of Art, The University of Chicago

Nandita Jaishankar
Senior Manager, Programs & Editorial
Serendipity Arts Foundation, New Delhi

Arushi Vats
Former Editorial Manager
Serendipity Arts Foundation, New Delhi

INTRODUCTION: IMAGINABLE WORLDS

ORIANNA CACCHIONE, NANDITA JAISHANKAR
& ARUSHI VATS

*The glitch challenges us to consider how we can "penetrate ...
break ... puncture ... tear" the material of the institution, and,
by extension, the institution of the body.*

—Legacy Russell, *Glitch Feminism* (Verso Books, 2020)

On February 11, 2020, the World Health Organization named
the novel coronavirus that was spreading throughout the world
COVID-19. Highly contagious and virulent, COVID-19 presented
with a dry cough and flu-like symptoms. Early attempts at
containment—national lockdowns, travel screenings, border
shutdowns—failed to stop, let alone slow, its spread. Within
a month, the World Health Organization declared COVID-19 a
pandemic. Seemingly overnight, life around the world halted,
case numbers rose, hospitals filled to capacity, and people died
alone in still unfathomable numbers—over six million people—
worldwide.[1] Governments declared states of emergency.
Many forms of work stopped, global supply chains stalled,
and shortages appeared. The pandemic emerged as a glitch, a
marker that something had gone wrong, revealing weaknesses,
unveiling unequal and imbalanced structures, and laying bare
questions of life, crisis, and planetary systems. Fed up and
called to act, people assembled to create popular movements
and protests emerged on a level not experienced in decades.

Early in the COVID-19 pandemic, during prolonged lockdowns
and social distancing measures, an accelerated pivot to the
"digital" as a dominant mode of engagement produced new
technologies of sensing, knowing, inhabiting, and transcending
the anthropic. From Zoom meetings to food delivery to video
games and Peloton classes, digital platforms have changed the
ways we orient ourselves in society.[2] Accessed and enacted

through devices, interfaces, algorithms, technologies, and capital, the digital social results in a sensorial regime of the many and the few—limited to those who have the means to afford both the necessary devices and internet connections and reaching many but isolated individuals. While dominant online platforms and digital tools assert conciliatory relations with structures of oppression, strategies and modes of subversion and occupation of such spaces are evolving in response. This has resulted in diverse topographies for both institutional entrenchments and revolutionary solidarities.

Entering its third year, the COVID-19 pandemic continues in waves as the virus mutates from Alpha to Delta to Omicron variants, still not endemic. Time has been suspended, extended, transformed. Parts of the world have abandoned attempts to control or avoid the virus, resigned instead to live with it. Still others remain obstinately committed to the increasingly unattainable strategy of COVID zero. The state of emergency has become permanent, easing into the habitual. Yet, this habituation of emergency is tied to neoliberalism, which emphasizes the individual over the institution in an attempt to evade systemic issues, biases, and harm: for example the call to change individual behavior as opposed to addressing large-scale issues in public health systems. Media theorist Wendy Hui Kyong Chun argues, "Neoliberal subjects are constantly encouraged to change their habits—rather than society and institutions—in order to become happier, more productive people; to recycle rather than regulate in order to save the world."[3] In this model, by the time we understand something—a pathogen, a weakness in the system, a virus—it has already disappeared or changed, like the vaccines that were so quickly formulated and put into production.

Across and alongside the lines of the pandemic and its distributive failures ran the strongest current of popular movements and social protests the globe has witnessed in recent decades— Black Lives Matter (USA), Yellow Vests Movement (France), the anti-Citizenship Amendment Act protests (India), the Hong Kong Protests, and numerous demonstrations demanding social and environmental justice in Latin America, to name just a few. It was evident to us, as the editors of this volume, that concerns of art making and signification had trampled the walls of art institutions to take to the streets—and so must this publication. These unique conditions, emanating from collapses and surges seeping into and exceeding the pandemic, prompted the need for critical dialogue. They have provoked us to reconsider our approach to dialogic and durational research that traces the arc of a project from its conceptualization to its realization in an event. Instead we conceived a methodology that can undertake transhistorical,

planetary, and rhizomatic journeys that will continue to reverberate as frequencies beyond the physical bounds of this publication.

Through this publication, we hope to transform the temporal mark of the last two years and by extension the COVID-19 pandemic into a research framework—an order of signs and gestures that thwart, distend, or invert conventions of being within and outside of the digital. Together, the voices of artists, theorists, playwrights, authors, journalists, and designers create moments of disturbance within the prevailing discourses of art, digitality, dominance, extractivism, and institutional complicity. These disruptive responses in diverse formats—long-form essays, conversations, photographic essays, artworks, fiction writing, even a glossary—expand on the shared and diverse forms of emplacement, crisis, and resistance across geographies and histories from South Asia to the Americas and back again. Taken together, a framework emerges that can enable asynchronous, autonomous, and interconnected research on urgent and necessary questions that confront us.

Practice

The first section emphasizes the emancipatory power of art forms and artists who have often been marginalized, excluded, or overlooked from discussions of the visual and performing arts. From games to digitally distributed performances and Dalit art, the included scholars, designers, and directors speak to the radical mandate of art to envision other ways of being in the world.

A conversation between media and game theorists Ashlyn Sparrow and Patrick Jagoda, "Pessimistic Futures: Black Worlding through Games," proposes a framework for modeling the materiality of extant futures. Sparrow and Jagoda argue that games occupy a powerful and perhaps emancipatory position in our political climate in their ability to help us co-create different, more equitable futures.

A static charge runs between scholar and critic Trina Nileena Banerjee and theater director and professor Amitesh Grover in their conversation on cyber theater, digitality, and evolving notions of embodiment and proximity. Together they maneuver toward dissent in a framework of panoptic surveillance. "Assembling in Isolation: The Politics of Virtual Performance in Amitesh Grover's *The Last Poet*" pivots the conversation from the processual and improvised gestures Grover and his team adopted as a new praxis during the pandemic to the phenomenology of social isolation to create a network of allied concerns regarding truth, memory, and public life.

Suraj Yengde's "Dalit Art" claims the terrain of life as the purpose of art. For Yengde, Dalit art regards living not simply as survival, but as a project of resistance, imagining, and building a concrete reality that rejects domination. He presents us not merely with the possibility but also with the actuality of solidarities that are embedded in the practice of Dalit art and its future(s).

Touch

In the book's prose and poetry contributions, relationships are mediated through loss, isolation, mourning, displacement, departure, and separation. This section speaks to terms of engagement but also to the interfaces that distill and produce connections between people who might exist in spaces oceans apart.

In Jeet Thayil's short story "How to Leave a Husband" a ferry moves between two continents, and in a journey of startling significance the ferry assumes the power of placelessness as it moves between a point of origin and an unwelcome future. Interestingly, this sense of an unknown future is itself a marker of a time we now refer to as "pre-COVID," a metaphor for life at the precipice of impeding crisis and uncertainty with which 2020 began.

Leticia Bernaus's "We Are Safe Here" complicates the ways touch and other senses are mediated through screens, pages, and other digital formats. For this expanding gatefold, images and words come together to suggest the intimacy of touch, dreams, and identity without their immediacy. Importantly at a moment when daily life is increasingly reliant on and experienced through social media, digital interfaces, and new technologies, this shifting landscape of words and images suggests the question: how can we feel a sensation if we can only see its digital representation?

In Siyanda Mohutsiwa's "Texts from the End of the World," a fictionalized account of pandemic life is captured and mediated by the clipped and truncated format of SMS. In this text exchange between two students, the global experience of COVID-19 is recounted through extended temporalities when conversations unfold over months, not minutes, and across unknown distances. In the back and forth punctuated with wit, half thoughts, and emojis, the characters evoke the experience of daily life, loss, and family drama in the midst of uncertainty.

Structure

The final section brings together two essays and a glossary that analyze institutions and infrastructures that organize daily life. These contributions radically critique the structures and

hierarchies of race, class, and gender to puncture illusions and consider other possible institutional and social structures.

Uzodinma Iweala's "Signs of the Times" is a powerful reckoning with the miasma of white supremacy. Part personal essay, part stocktaking of art's place in American society and its institutional legacies that shape our present, Iweala asserts the necessity of uncertainty that may prompt unease yet creates the conditions for hope.

In "H for Humidity: Keywords and Notes on Infrastructures, Water, and Water Engineering in Singapore," artist Ho Tzu Nyen composes a glossary that compiles terms and creatively citational definitions at the intersection of hydrology and humanitarian discourse. Terms as diverse as "lubricant" and "revolutionary infrastructure" are paired with citations from a wide-ranging group of thinkers, such as media theorist Keller Easterling and sociologist and philosopher Zygmunt Bauman. Part of Ho's ongoing project, *The Critical Dictionary of Southeast Asia*, the glossary examines global subjectivities that are produced and regulated by contemporary governance, infrastructure, and technologies.

And in Meena Kandasamy's "All Women Are Workers, Not All Work Is Waged: Three Tales of Surviving the Pandemic in Puducherry," the figures are flesh and blood, women moving through a city that is contending with injustices both invented and inherited. Kandasamy observes with a keen eye the lives of female workers, as she too must reckon with the weight of motherhood and making a living. Two portraits of women emerge over the course of her narration, while a self-portrait slips into the fold of dependence and care that sustains the act of living.

Notes

1. At the time of writing, 6,513,939 people had died from COVID-19. Dashboard by the Center for Systems Science and Engineering (CSSE) at Johns Hopkins University, https://coronavirus.jhu.edu/map.html.

2. Benjamin Bratton, *The Revenge of the Real: Politics for a Post-pandemic World* (London and New York: Verso, 2021), 48.

3. Wendy Hui Kyong Chun, *Updating to Remain the Same: Habitual New Media* (Cambridge, MA: The MIT Press, 2016), xi.

PRACTICE

PESSIMISTIC FUTURES:
BLACK WORLDING THROUGH GAMES

A DIALOGUE BETWEEN
PATRICK JAGODA AND ASHLYN SPARROW

ASHLYN SPARROW: Why are futures important? Why do we need them, especially given the current state of the world as we have this conversation in 2022?

PATRICK JAGODA: Whether or not we *need* futures, they still occupy our imaginations. And then, beyond imaginaries, material futures arrive, as this barely registered present moment transitions into the next and myriad potentials become actualized as concrete, if still ephemeral, states. In the longer term, such changes coalesce into more concrete, and sometimes apprehensible, states.

I like that you used "futures" in the plural, because it is limiting to imagine only a single, monolithic future. Thinking about the future might serve teleological projects, such as nation building or technocapitalism, that are invested in a narrower and more or less deterministic range of futures. The problem is that invoking the future doesn't reflect the uneven velocities of change, untimely emergences, unpredictable swerves, and coexisting worlds of which history has shown us ample evidence. In a well-known quotation, which is attributed to the science fiction writer William Gibson, he observes, "The future is already here. It's just not evenly distributed yet."[1] This pithy line captures something important about uneven access to technology and resources around the world. At the same time, the singular idea of "the future" still reflects the belief in a unitary and preordained world—if we are being honest, someone else's world—that simply has not manifested everywhere "yet."

That "yet" is a common way of thinking that isn't unique to Gibson. That formulation is limited—arguably even more so in

our present. When you invoke the future in the context of the current state of things, it's difficult to think forward from the mess we're in. In an interview about the concept of hope, philosopher Brian Massumi argues that the only way to make hope useful is to disaggregate it from the idea of "expected success" or "optimism."[2] We need only conjure problems such as climate change, unprecedented global inequality, Western political polarization, disinformation across social media, biodiversity loss, the Russian invasion of Ukraine, and much more to see that *the* future, if we think of it as a singular state of things to come, is not bright.

For me, two ways of thinking about the future are particularly hopeless. The first is a religious or romantic approach to the future as imbued with messianic hope or the possibility of being saved. This is a baseless attachment to the idea that the balance of the world will someday be restored by an external figure. The second approach, which is related, is a rational faith in the capacity of technological systems to solve all human problems. This way of thinking, which was so common during the Cold War and remains central to contemporary Big Tech, is predicated on the idea that the future can be known and controlled. In distinction to these two versions of the future, futures in the plural have more to do with expanding the potentials of the present through unexpected ways of thinking, alternative histories, and modes of imagination that exceed normative parameters. A process of proliferating futures has much more in common with the game development that we've done together over the last decade, much of it connected to speculative design. This term "speculative design" has been elaborated by critical designers Anthony Dunne and Fiona Raby.[3] It refers to designing and making objects that help us think through both futures that we want and ones that we'd like to avoid. I want to be clear that I don't think this way of thinking is necessarily any more *hopeful* about the likelihood of a better future but it does provide more room to maneuver through the present.

When we've discussed futures, you've often joked around with me that you're an Afropessimist. But I also know you're never *really* joking when you say this. Maybe what you mean by that might be a more culturally and historically specific version of what I'm sketching out in my response to your question, combined with a consciousness of histories of human subjugation, racial inequality, and structural violence that cannot be discounted in any imagination of futures. Could you say more about that?

AS: **The future's approach, as you so wonderfully articulated, feels semi-religious. We often see a fixation on humanity's redemption, an incessant focus on salvation. For me, these visions require such**

large leaps of faith that, regardless of their rational, idealistic, or analytical approaches, they never show you how we got from here to there, because they never truly grapple with the full magnitude of our historical past and present. Such visions look at societal victories and disregard the oceans of violence and neglect aimed at so many peoples across history. But a narrative of progress is seductive, especially in a colonial nation, bolstered by mass enslavement, like the United States, that continues to wrestle with the gravity of its past.

For me, Afropessimism is a means to understand structural violence. It focuses on a grammar of Black suffering created during the Middle Passage, in which millions of enslaved Africans were forced across the Atlantic Ocean, and the ongoing effects of racial slavery. Frank B. Wilderson III, one of the founders of this philosophy, states that "Blackness is coterminous with slaveness."[4] He borrows this way of thinking from Orlando Patterson, who theorizes slavery as a dynamic between social death and social life: slave and human. Chattel slavery robbed Africans of their personhood through social, cultural, political, and physical violence on the plantation. Through this process of social death, the Black subject was born. Racialized slavery has no analogies to other historical forms of violence. Blackness and its histories live within the paradoxical state of existing and not existing. Emancipation did not give way to freedom. Instead, as the structures of oppression shift, the Black subject's position will forever remain unchanged. Thus, Afropessimism puts forth an ontological distinction between Blacks (slaves) and humans, with the latter category including non-Black oppressed identities. It reframes one's relation to systemic violence and brings forth a fundamental antagonism that shapes our society: anti-Blackness.

What draws me toward Afropessimism is that it's not oriented toward futures, nor does it provide methods to gain agency and power. In his essay titled "Afro-Pessimism: The Unclear Word," Jared Sexton draws from Joshua Dienstag and describes it as a way of "withstanding the ugliness of the world—and learning from it." He goes on to argue, "in its formulation of power, and particularly of the nature and role of violence, Afro-Pessimism does not only describe the operations of systems, structures and institutions, but also, and perhaps more importantly, the fantasies of murderous hatred and unlimited destruction, of sexual consumption and social availability that animate the realization of such violence."[5] In this space, I can sit with the abject horrors of the past, stay with

macro- and micro levels of structural violence, and perhaps be guided by it. By thinking through the end of the world and a dismantling of anti-Blackness, there is a future so radically different from the world we inhabit, an afterlife of human subjugation.

PJ: You lay out the ideas motivating Afropessimist political aesthetics really clearly. An important part of all of this has to do with an initial orientation toward the past over and above the future—an orientation that is also central to Afrofuturist aesthetics. This is not to say that the future cannot bring significant change, but only that our construction of the future is embedded in the past and the unfolding present.

What you've said makes me think of Fred Moten's meditation on freedom that is so important to Black studies. His ideas build on many of the same convictions but take us in a slightly different direction. He asks, "Is knowledge of freedom always knowledge of the experience of freedom, even when that knowledge precedes experience?" Moten answers this question by drawing from the Black radical tradition. That tradition pushes against the white Enlightenment concept of freedom. But it doesn't simply reject it. For Moten, this has to do centrally with improvisation. He argues that the Afro-diasporic tradition "improvises through horror."[6] The horror genre certainly offers one formal frame and aesthetic mode for thinking through the historical subjugation and ongoing violence that you described. Recent popular cultural examples of this might include Jordan Peele's film *Get Out* (2017) and Nia DaCosta's *Candyman* (2021). Science fiction is another genre that occasionally helps us think about how dehumanized and enslaved people invent freedom. Someone born into American slavery had never experienced certain kinds of freedom. What the "North" or concrete prospects of freedom might have meant to a Black person born into enslavement on a plantation in the eighteenth or nineteenth century might have been largely speculative, short of any lived experience of that type of freedom. And yet it's precisely by escaping enslavement that a person could invent a freedom, certainly a complicated freedom, that did not preexist this act. Improvising with the future builds not on hope in a better future per se but upon a faith in the potentials of one's body and collectivity in constituting a future that introduces difference to repetition. I see a similar move occurring in Alisha B. Wormsley's usage of the phrase, inspired by Afrofuturist Florence Okoye, "There are Black People in the Future."[7] Again, this statement is not one of hope about the status quo somehow yielding survival

or substantial change but instead of a prescriptive insistence in the face of past horrors that Black folks have faced.

AS: This conversation is taking us into the popular arts. In *Red, White & Black: Cinema and the Structure of U.S. Antagonisms*, Wilderson asks, "can film tell the story of a sentient being whose story can be neither recognized nor incorporated into Human civil society?" Sexton builds on this question by including "art, literature, music, thereafter, or for that matter, theory?"[8] Patrick, what about games?

PJ: As you know, that's a tricky question! To the ear of people immersed in fine art or literature, your question might sound downright perverse. How could a game accomplish something so complex and nuanced? To a sizable part of the population, certainly above the age of 40 or so, the word "game" might evoke frivolous pastimes—say, a card game like *Uno* or a board game like *Monopoly*. Maybe this calls to mind a card game like Poker or Blackjack that is associated with gambling. Others might think of video games such as Fortnite or the Grand Theft Auto series that carry the usual associations with addiction, violence, and youth cultures. At most, for many people, the most elevated form of a game might be chess or *Go*, though even that operates in the realm of strategic abstraction and not the embodied materiality that you're invoking.

 Of course, as you also know, I think those associations are limited at best. As game designers, we frequently interface with the incredibly rich social, political, aesthetic, and affective palette that games provide. Take, for instance, Brenda Romero's board game about the Middle Passage. I've heard her tell the story of her seven-year-old daughter coming home from school and not understanding what the Middle Passage was, or why it was so horrifically significant to American history. So, in response, Romero created a prototype of a game entitled *The New World* that had players take the role of slave traders navigating the Middle Passage. This became part of her The Mechanic Is the Message series, which took on a series of sociopolitical traumas and genocides, including the Cromwellian invasion of Ireland by England in the mid-seventeenth century, the Trail of Tears that saw the ethnic cleansing and displacement of Indigenous people in the mid-nineteenth century, and the Holocaust. One element of such games that is important is that they're not just stories about these events or representations of them. As the title of Romero's series emphasizes, playing on Marshall McLuhan's famous pronouncement that "the medium is the message," it

is that the mechanic is the central means of communication.[9] A "mechanic" signifies what a player *does* in a game. Across everything from board games to video games, this encompasses the actions, interactions, and improvisations that move the state of a game forward.

In the case of Romero's games, the mechanics often ask players to act in ways that make them complicit with systemic violence or structural inequality. Many video games do this as well. The independent game *Braid* offers a critique of the post-World War II technoscientific complex, masculinity, and gamification by flipping the hero narrative of the Super Mario Bros. series. Another game that comes immediately to mind is the third-person shooter *Spec Ops: The Line*, which uses the complicity of player involvement to criticize the military-industrial complex and American imperialism.

I'm very aware that all of the examples I'm offering are by white game designers, and that tells you something about the homogeneity of the contemporary game industry. Of course, there are important serious and experimental games by BIPOC designers that relate to this conversation, even as they're less common, at least at this point in time. I think immediately of Kenyatta Forbes's card game *Trading Races*, which is a game created for Black culture and is very much about world making through the proliferation of different modes of Blackness. Another example that comes closer to the futurist and pessimist orientation might be micha cárdenas's augmented reality game *Sin Sol (No Sun)*, which explores ways that trans and disabled people are disproportionately impacted by climate change. This is a game that operates from within the realm of climate emergency and structural inequality.

What do you think? Can games capture what Wilderson is after, especially the experiences and stories of Black people who are, in so many ways, excluded from the category of the human? More than this, can games help us co-create futures and worlds that achieve some kind of freedom, even if there is no preceding experience that makes such freedom knowable or sensible?

AS: Theoretically, I think this is a thousand percent possible. However, it's based on a few assumptions that would have to change within the industry as a whole. First, there would be more people of color, especially Black people, studying and designing games. If we cannot diversify the industry to include other voices, then our stories and perspectives will continue to go unheard. Second, the industry would need to really listen to and trust people of color. This goes beyond posting on social media, crocheting

hats, wearing pins, or chanting slogans. While this is a start, it means that the default perspective will get challenged. People will feel uncomfortable but everyone will need to sit with that discomfort in order to move forward. *Trading Races* balances this really well by asking its players to answer the question of what is Blackness and what are the levels of Blackness. It exposes stereotypes, biases, thoughts, opinions, beliefs, and cultural understandings of the individual but also potentially the collective. Black people are used to having these conversations in ways that white people might not and this shows when playing the game. Finally, game designers need to recognize their position in relation to the broader discipline of design. They need to focus less on games as entertainment and instead take on the historical, sociopolitical, and cultural ideologies that underpin the industry.

One of my favorite definitions of a game comes from game theorist Jesper Juul. He states that a game is "a rule-based formal system with a variable and quantifiable outcome, where different outcomes are assigned different values, the player exerts effort in order to influence the outcome, the player feels attached to the outcome, and the consequences of the activity are optional and negotiable."[10] Many definitions of games have a focus on "artificial conflict" but with Juul's definition everything is constructed and it's not clear who is assigning values or why. It feels similar to real life and all of the social constructs and systems we've put in place: education, healthcare, justice, poverty, civics, gender, sexuality, and even race. With the right mindset, I truly believe game designers could inhabit an incredibly powerful and thoughtful position within our political climate.

PJ: I like that blueprint for cultural change. Could you give an example where you've seen a glimpse of this kind of possibility in the game design work we've done together?

AS: Hexacago Health Academy (Fig. 1) is a good example from our collaborations. This was a program where high school students on the south and west sides of Chicago could use board game design as a mode of research and knowledge production.[11] Through this program, we were able to facilitate communication between students, and have them explore issues of police brutality and the criminalization of marijuana. One of the resulting board games, *Weed City*, was designed by a group of Black and Latinx high school students in the summer of 2016. In the students' design document, the game

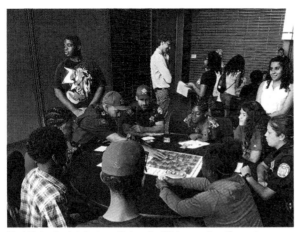

Fig. 1 High school students and University of Chicago police officers play a game together at the Hexacago Health Academy program (2015-ongoing). Courtesy of Game Changer Chicago Design Lab.

is described as an attempt to "teach life skills about what going down the wrong path can lead [to] It teaches you what the streets are like and what can actually happen to you if you follow the path of wanting to live in the streets." The game takes place in the fictional city of Hexacago, an abstract representation of Chicago neighborhoods and its city train system. Players are randomly assigned the role of either a drug dealer or police officer based on their card selection. Drug dealers are trying to place ten marijuana tokens throughout the city without being caught. Officers must land on the same hexagonal space as the drug dealers in order to lock them in prison and confiscate the marijuana left behind in the neighborhoods. Upon a closer reading of the game's mechanics and development process, *Weed City* reveals the design team's utopian worldview. Shooting is not a mechanic in the game. At no point are the drug dealers' lives ever threatened. At its core, *Weed City* is an elaborate game of hide-and-go-seek between drug dealers and police officers. This comparatively idyllic relationship between these historically adversarial groups, especially in terms of race, was a major point of contention for the students given the Chicago communities in which they live.

I remember the final day of the Hexacago Health Academy program took the form of a showcase: an opportunity for friends, family, university faculty, staff, and other community members to play the final versions of the students' games. We watched three University of Chicago police officers sit down to play and discuss *Weed City* with the student team that had designed it. In a surprising twist of fate, all officers were assigned the role of

drug dealers, and the students were the police officers. It was at that moment, the students got what they were truly looking for: a way for police officers to have non-violent interactions with people of color in their community. This session of the game was remarkable. To me, this is the transformative possibility of game design and game play. How do you see our thinking about game design and social change itself changing over the years?

PJ: It took us several game projects to reach the position that you're describing here. For many years, you and I worked together at the Game Changer Chicago Design Lab, creating games with and for BIPOC students on the South Side of Chicago.[12] This early point in our collaboration was both influential to where we are now and filled with illuminating false starts. For example, the game lab used techniques such as "story circles" and "human-centered design." Both of these methods focused on youth stories and experiences, rather than adult designer assumptions, as the starting point for designing games. For example, this was the case with a couple of games we created about sexual harassment and sexual violence. These included the interactive narrative *Lucidity* (2013) and the game *Bystander* (2014–16) (Fig. 2). These prototypes taught us how to include youth in South Chicago in the design process

Fig. 2 Screenshot from the *Bystander* (2014–16) video game.
Courtesy of Game Changer Chicago Design Lab.

and they gave us the opportunity to start making games that approached individual traumas and complex topics. The limit of these games was that they still operated within an "educational games" frame. In part because we were working with public health researchers, we treated games as problem-

solving vehicles that might embed a critique of rape myths—
the efficacy of which could be evaluated through a standard
pretest/post-test research design.

There is nothing inherently wrong with educational games,
and there is a time and a place for them, but given our deeper
artistic investment in games, this instrumental approach struck
us both as limited. By 2016, we started thinking more about
the concept of "embedded design" that comes from Mary
Flanagan and Geoff Kaufman. They argue that in order to
produce behavioral change or substantial sociopolitical results
through games, especially when dealing with challenging,
complex, or sensitive issues, it is important to think about
non-didactic or indirect ways to reach players.[13] This way of
thinking resonated with many of our instincts, if not our practice
at the time. For instance, I know we both consider one of the
most effective treatments of suicide in video games to be the
big-budget game *Life Is Strange* (2015) and not any educational
game that overtly focused on that topic. *Life Is Strange* is not
a game that is explicitly about social and emotional health,
bullying, depression, or suicide, but it embeds these themes
within a complex experience of a deep multilinear narrative
game about high school that differentiates itself through a
speculative capacity to rewind time. Instead of treating
depression or suicide as an event, it integrates them into the
broader texture of historical and interpersonal events. Around
the time we were exploring embedded design, we met several
artists including Heidi Coleman (who works in theater and
performance) and Marc Downie (who works at the intersection
of algorithmic cinema and virtual reality). Over the years,
we formed the Fourcast Lab collective.[14] This group began to
create a series of alternate reality games that combined game
mechanics with live-action performance, live streaming, and
numerous media platforms. Players of these games encounter
characters through a combination of online and in-person play
that incorporates narrative and puzzles via platforms such as
Twitch and TikTok. I'll give one example of how this work took
us from educational to embedded design. Our first game, *the
parasite* (2017) (Fig. 3), was created for about 1,750 incoming
first-year students at the University of Chicago. The premise of
this multi-month game was that a secret society called PS had
existed at the university since the late nineteenth century. This
immediately called to mind secret societies that are part of the
popular imagination, such as Yale's Skull and Bones. We did not
treat PS as a fictional organization but used various techniques
to manifest it as a real group in the world. As it turned out, PS

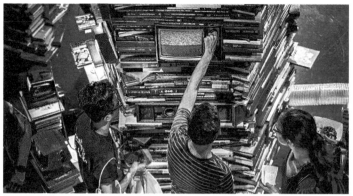

Fig. 3 Live-action play in the *parasite* alternate reality game (2017).
Photograph by Freddy Tsao.

did not engage in the hazing and self-reproduction that is so
common to secret societies, fraternities, and sororities, but
instead engaged in a form of self-obsolescence and perpetual
change that meant that the current members would look very
different from past members.

When the team (which also included Heidi Coleman and
Kristen Schilt) pitched *the parasite* to the University of Chicago
administration, it was as a game about diversity and inclusion.
These weren't really our preferred terms. We instead preferred
the language of "difference" and "dissensus." But diversity and
inclusion made us legible and allowed us to enter conversations
with administrators, faculty, staff, and students across the
university. The game did address diversity and inclusion
explicitly, including through an event at the Center for Identity
and Inclusion that made the center's resources more visible
to incoming students. But even as diversity and inclusion were
operative categories, we were interested in moving beyond
quantifiable inequities (the transformation of which is necessary
but not sufficient) toward qualitative aspects of campus climate.
These elements included thinking about sexual harassment,
sexual violence, microaggressions, and experiences of BIPOC
and LGBTQ students that have to inform the transformation
of an institution from a historically homogeneous to a more
heterogeneous space. An educational game might have been
overtly *about* diversity and inclusion. Instead, we used game
design to invite participants into actions and behaviors that
might promote these values. The game was *about* a secret
society and a magical room that appeared on the campus once
every eleven years. That was the story that kept students
interested and engaged. But the 121 unique challenges and
puzzles that drove the game required forms of collaboration,

exposure to faculty and resources, awareness of the benefits of difference, and other actions that moved the story forward. The gameplay *embedded* the kinds of orientations and skills that students would need in order to transform the institution in which they'd be participating for the next four years.[15]

We learned so much from *the parasite*, and that led to a series of alternate reality games about climate change (*Terrarium* and *Cene*) and pandemics (*A Labyrinth* and *ECHO,* Fig. 4) over the next

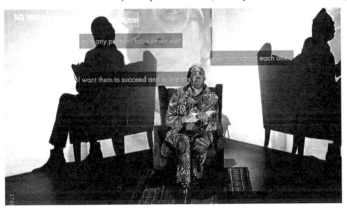

Fig. 4 Screenshot from a live-streaming sequence of the *ECHO* (2020) pandemic game. Courtesy of Fourcast Lab.

several years. These games have been focused on big contemporary problems, but they have also used transmedia storytelling and remote live-streaming play to invite collectives of players to imagine alternative futures.

Those lessons finally brought us back to video games. We've been collaborating on the game we're calling *After Life*, which incorporates the very principles you described. At the production end, we're working with a small group that foregrounds BIPOC and women. At the creative end, we're tackling the broad topic of racial capitalism that requires us to sit in a space of ambivalence (which is not to say apathy) and discomfort in which negativity is our constant ally. In an American culture of pathological positivity, an honest engagement with the histories of slavery, militarism, or control systems can be taken as an incapacity to move beyond the past or an unproductive cynicism. We're trying to defamiliarize that knee-jerk response, as speculative fiction so often does, by telling a history of a possible future, starting several hundred years down the line and gradually working back to the present. Unlike an "educational" or even standard "serious" game, the game is not so directly *about* racial capitalism but it incorporates so many aspects of that system into the broader world in which our series of interconnected narratives unfold.

In at least some respects, our ambition with *After Life* is to create a game that operates as "encyclopedic narratives" once did in literary fiction in terms of absorbing and refracting so much of a present culture and the histories of violence upon which it is built. Our version of that shares much with approaches ranging from speculative design to Afropessimism, which we've been discussing.

AS: That's exactly right. Can you say more about what you mean by encyclopedic narratives, since it's a category we've discussed a few times during our collaboration?

PJ: Absolutely. The term was coined by literary critic Edward Mendelson in a 1976 article. He used the category of encyclopedic narrative to describe maximalist literary works such as *The Divine Comedy*, *Don Quixote*, *Moby Dick*, *Ulysses*, and *Gravity's Rainbow*. For him, this is partially a national genre, so that an encyclopedic author is trying to capture the entirety of a nation's social and linguistic dimensions, and key genres and styles, within a single literary work. As he puts it, "Encyclopedic narratives all attempt to render the full range of knowledge and beliefs of a national culture, while identifying the ideological perspectives from which that culture shapes and interprets its knowledge."[16]

There are both limits and promising aspects of this category in terms of the type of work we're doing together. The downside of this genre is these narratives tend to be nationalist, imperialist, and masculine, though certainly not in every case. We see this even in the genre of the modern encyclopedia itself, which is alphabetically ordered and aspires to totalizing classification in the way it comes up with a general system to assimilate and reduce, to make known, all of the Earth's diversity. This is an impulse that remains alive and well in contemporary fantasies that surround big data. On the upside, the category invites a generalist (if never comprehensive) approach to our complex world. In so many ways, you cannot make sense of what is going on around us without thinking through the connections among categories such as technology, economics, politics, and culture. I would argue that games already invite a kind of systems thinking, arguably even more than novels or other narrative forms. So the form seems perfect for creating an (anti-)encyclopedic narrative in the twenty-first century. To finish our conversation, could you say a little more about how we're thinking about our *After Life* project as a materialization of these ideas?

AS: While I don't think there exists a game like what Wilderson is after, or a game equivalent to Mendelson's idea of encyclopedic

narrative, I think we're both grappling very hard with these elements and histories in *After Life* (Fig. 5). Honestly, I feel like this game becomes more relevant as time goes on, especially with the emergent reality of the Metaverse projects being taken up by companies like Facebook and Microsoft.

The premise of *After Life* follows a young Black woman who asks the players to call her X. She sits in a bar located within the virtual world Omniverse. X cannot remember much of her life before this point, however she knows, with visceral

I look across the unfamiliar factory. I don't know what they produce here, but I have a bad feeling. This isn't likely to turn out well.

Fig. 5 Concept art from the in-progress *After Life* game project.
Photograph by Patrick Jagoda and Ashlyn Sparrow.

clarity, that she's lost her son. At the bar, she meets a private investigator, named Inspector Spector, whom she has hired to look for her son, though she can't remember the details of this either. As he searches, she attempts to retrace her steps through the Omniverse. The inspector eventually reappears with a lead: her son was last seen in a strange laboratory. At the center of the Laboratory, X finds twelve coffin-shaped pods connected to a number of cables. These pods contain hibernating human bodies, some that look like young children, others that are adults. They are all alive. To find her son, X must connect to each pod, one by one, and learn the story of each person, and uncover who she is and her relationship with these individuals. Those genre-bending science fiction narratives cover a wide-ranging history of the future. The stakes exceed X's own search and have implications for the fate of all of humanity.

This narrative frame enables us to touch on broader sociocultural issues and project the ramifications of our present-day actions into the future. For example, in one of the stories, we explore the privatization of science and lunar colonization. In another, we explore the aftermath of a nuclear

war. But we are not just focused on a narrative perspective; we are also interested in thinking through video game culture, genre, and mechanics. How might ludic genres like endless runner, roleplaying game, or open-world adventure be used to support a persuasive critique of issues linked to racial capitalism? We're trying to create a game that can tackle the major social, political, technological, and cultural issues of our present day. We're trying to do this in a medium-specific way that relies on one of the major art forms of our historical moment: games. This is a very exciting but daunting undertaking. Fortunately we are not alone with this endeavor! For the *After Life* project, we have assembled a fantastic group of new collaborators, including Sarah Gavagan (concept artist), Kent Lambert (sound designer and composer), Dean Rank (2D artist), Dannielle Rogers (3D character modeler), and ChiaHao Liu (3D environmental modeler). I am eternally grateful for such amazing collaborators on projects like this!

PJ: Maybe that's the least pessimistic possible note on which to end a conversation that began with violent pasts and unpromising futures. If there's one concept that still gives me a sense of joy—sometimes (perhaps naively) even hope— it's artistic collaboration, especially with you. But that's a topic for another conversation and some other future.

Notes

1. For one account of this line, see Pagan Kennedy, "William Gibson's Future Is Now," *The New York Times*, January 13, 2012.

2. Brian Massumi quoted in Mary Zournazi, *Hope: New Philosophies for Change* (Annandale, Australia: Pluto Press Australia, 2002), 211.

3. Anthony Dunne and Fiona Raby, *Speculative Everything: Design, Fiction, and Social Dreaming* (Cambridge, MA: The MIT Press, 2014).

4. Frank B. Wilderson III, *Afropessimism* (New York: Liveright Publishing Corporation, 2020), 102.

5. Jared Sexton, "Afro-Pessimism: The Unclear Word," *Rhizomes 29* (2016): 6, 24, https://doi.org/10.20415/rhiz/029.e02.

6. Fred Moten, "Knowledge of Freedom," *CR: The New Centennial Review* 4, no. 2 (Fall 2004): 275, 303.

7. Alisha B. Wormsley, "There Are Black People in the Future," in *Black Futures*, ed. Kimberly Drew and Jenna Wortham (New York: One World Publications, 2021), 44–47.

8. Frank B. Wilderson III, *Red, White & Black: Cinema and the Structure of U.S. Antagonisms* (Durham, NC: Duke University Press, 2010), 96.

9. Marshall McLuhan, *Understanding Media: The Extensions of Man* (New York: McGraw-Hill, 1964).

10. Jesper Juul, "The Game, the Player, the World: Looking for a Heart of Gameness," in *Level Up: Digital Games Research Conference Proceedings*, ed. Marinka Copier and Joost Raessens (Utrecht, Netherlands: Utrecht University, 2003), https://www.jesperjuul.net/text/gameplayerworld/.

11. Hexacago Health Academy is a three-week game-based summer program that engages high school students with major health issues through game play, interactions with STEM and health professionals, and mentoring. In the first year of the program, the curriculum was devoted to sexual and reproductive health while year two focused on alcohol and drugs. For more information about Hexacago Health Academy and its health outcomes, see https://www.ncbi.nlm.nih.gov/pmc/articles/PMC8205025/.

12. The Game Changer Chicago Design Lab is located at the University of Chicago and is part of the Center for Interdisciplinary Inquiry and Innovation in Sexual and Reproductive Health (Ci3). This lab fosters research across the humanities, arts, social sciences, medicine, and public health. For the most part, our project involves designing games to improve the social and emotional health of youth of color.

13. Geoff Kaufman and Mary Flanagan, "A Psychologically 'Embedded' Approach to Designing Games for Prosocial Causes," *Cyberpsychology: Journal of Psychosocial Research on Cyberspace* 9, no. 3 (2015): https://doi.org/10.5817/CP2015-3-5.

14. The Fourcast Lab is a transmedia design collective based at the University of Chicago. We create Alternate Reality Games (ARGs), pervasive games, cross-platform stories, and networked performances. While core members now include Heidi Coleman, Marc Downie, Patrick Jagoda, Ben Kolak, Kristen Schilt, and Ashlyn Sparrow, the lab's influence reaches far beyond these six individuals to include many University of Chicago faculty and staff as well as project-specific professional artists from the Chicago area. For more about the Fourcast Lab, see https://fourcastlab.com/.

15. For a fuller account of this game, see the "Improvisation" chapter of Patrick Jagoda, *Experimental Games: Critique, Play, and Design in the Age of Gamification* (Chicago: The University of Chicago Press, 2021).

16. Edward Mendelson, "Encyclopedic Narrative: From Dante to Pynchon," *MLN* 91, no. 6 (December 1976): 1269.

ASSEMBLING IN ISOLATION: THE POLITICS OF VIRTUAL PERFORMANCE IN AMITESH GROVER'S *THE LAST POET*

AMITESH GROVER IN CONVERSATION WITH
TRINA NILEENA BANERJEE

Introduction

In her essay "Save As ... Knowledge and Transmission in the Age of Digital Technologies," Diana Taylor writes: "... the embodied, the archival, and the digital overlap and work together and mutually construct each other. We have always lived in a 'mixed reality.'" Amitesh Grover's cyber-theater production *The Last Poet* was commissioned by the Serendipity Arts Foundation in 2020. It premiered at the festival, which was held virtually because of the COVID-19 pandemic, in December of the same year. The "mixed reality" that Taylor had indicated many years prior to the pandemic had become even more complex and difficult to navigate in a world where suddenly all public assembly was forbidden. It was not long ago that theorists like Judith Butler had reflected on the crucial role of performance and public assembly in contemporary politics the world over. Butler's post-2011 essays examined the various "occupy" movements that had shaken up the world since the Arab Spring. It was impossible to deny the role of the digital (especially social media sites) in providing the impetus for the concerted physical occupation of public spaces by masses of unorganized citizens in different cities across the world since 2011. However, Butler had also discerned a significant shift toward a new kind of corporeal politics in these movements, where traditionally gendered notions of public and private had begun to break down. Since 2014, India has seen several waves of such protests. These are movements that have involved the continuous and largely spontaneous occupation of urban and semi-urban public spaces by large groups of people—including students,

workers, and farmers—determined to place their critical political demands before a recalcitrant government. In late 2019 and early 2020, an as-yet-unprecedented occupation of a public square began in Shaheen Bagh by Muslim women, who were subsequently joined by many others. It was only with the sudden and unplanned lockdown following the beginning of the pandemic in India that the government was able to entirely shut down these protests, while causing the uprooting, immiseration, and death of numerous migrant workers across the country. The period after the lockdown also saw a series of targeted and draconian arrests of artists, activists, and intellectuals across the country. With little recourse to public protests for citizens, many of those responsible for these arbitrary incarcerations escaped public accountability.

It was with these political events in the background and the COVID-19 pandemic raging across the country, effectively causing all live performances to be suspended, that Grover conceived his project *The Last Poet*. It came together from the start as a collaboration between a team of digital scenographers, programmers, creative technicians, actors, and the writer of *The Last Poet*—playwright and dramaturge Sarah Mariam. Consequently, the play reflects the precariousness as well as the political and affective desperation that has irredeemably marked these bleak times. As Mariam wrote the script, Grover encouraged her to add more stories to an ever-expanding and floating city of memories. More stories meant more characters: performers playing an increasing array of individuals, telling infinitely flowing tales, moving from one memory into another—like rivers that could begin and end anywhere. It was a universe of "'multilogues," simultaneously live streaming from several virtual rooms—stories of diverse crises, loves, intimacies, isolations, and hopes. The play's introductory note describes the project:

> *The Last Poet* is a Cyber-Theatre production, featuring five actors. It is staged in a 3D Generative World integrated with multiple simultaneous live streams and interactive features. The experience is unique every time for each audience member, taking them through different pathways and narratives via a real-time algorithm. It is a multi-layered art form with theatre, film, sound art, creative coding, digital scenography, and live performance. This work is an attempt to explore ideas of *democratic theatre*

in cyber culture; it is a digital broadcast accessible to all. It is arguably India's first genre-bending broadcast of theatre-on-the-internet.

The Last Poet, from the first minute of its performance, reproduces the acute political despair and isolation of the dire times from which it was born. Fear and suspicion rule this world. The spectator, on a capricious journey in a dystopic virtual space, moves unpredictably from one dimly lit room to another, encountering scenes where one man—a poet, a father, a loner, a lover, a teacher—is being remembered in many different ways. But is it truly one man who is by turns being mourned, celebrated, and loathed? Or do we encounter a palimpsest of faces, voices, and lives lived—of poets, rebels, and incarcerated artists—emerging through these multiple acts of remembering, denouncing, and memorializing? Do we hear an out-of-sync chorus of ghostly voices resonating and uncannily amplified in resistance to the state's systematic and deliberate erasure of disturbing political realities? What are these realities? Is this a tale about a mythical man? A lament that mourns the disappearance of many exceptional artists who crafted language into agony in times of stifling repression? How do we remember those who were simply ruled out of existence in history? Such are the questions we encounter in this world.

From the very beginning of *The Last Poet* (and there are many simultaneous beginnings), the spectator is aware of her position as a voyeur much more acutely than in an ordinary performance space, such as a gallery, proscenium, or street. She is looking at faces she does not know in intimate proximity, hearing strange voices tell secret stories she does not immediately understand. This unfiltered nearness, in spite of the material presence of the mediating screen, is viscerally disturbing. By making one virtual choice or the other, blindly—much as in life—the spectator enters intimate spaces where she does not belong. She eavesdrops on stories of love, longing, and desperation that she feels she is not meant to hear. In this world, people—citizens, lovers, daughters, friends, rivals, neighbors, students, journalists—have been imprisoned in their separate cubicles. A room is merely a video camera and a screen; the speeches delivered and the stories told are not conversations: they are only the simulacra of a moment of listening and understanding that never actually took place. Each encounter feels like a secret rendezvous, at times ominous and claustrophobic, at others intimate and gut wrenching. The characters whisper clandestine tales—private mythologies and long-buried confessions—sometimes regurgitating them

breathlessly, without a pause, as if driven onward by some hidden compulsion (the game/the program/the algorithm?). Do the speakers see their anonymous listeners? Do the actors imagine an exchange of gazes as they look at their own faces reflected back on their personal screens? Recounting stories to themselves in their private rooms, as we all often do, these storytellers are prodded by the spectral presence of invisible others—namely, us—to choose one *qissa* or intimate memory over another. The spectator casts her vote: "*What would you like to hear about next: a wound, a butterfly, a photograph*?" Does the performer move like an android at her command? Or does he resist? Does the story have a life of its own? How many anonymous others are there? Is this veiled intimacy a trick that hides the secret of a missed encounter? Having once been missed, how many times will this impossible meeting be replayed? Whose memories are really at stake?

The floating city is a hall of mirrors where another past is reflected: a past where people met at demonstrations, read poetry and sang together in intimate gatherings, or exchanged glances in the corridors of universities. This is no longer that world. The city of *The Last Poet* is elegiac; it is dislocated, it mourns, and it despairs. The rooms are uprooted, the characters fearful and alone, and even in a futuristic dystopia, they are caught irrevocably in the past. They are many isolated feet walking the same roads alone while staying completely still. This is the paradox of the floating city: no one ever goes anywhere.

All the narrators, in their separate rooms, remember a poet they had once known. Are these the same poet? Or many different poets who were once incarcerated without cause or explication, guilty of crimes that no one was quite sure about? Who were they? What were the proper names that are never mentioned in the play? Lorca? Faiz Ahmad Faiz? Varavara Rao? Habib Jalib? We do not know. Yet, the poet's invisible prison, a place we never see, is reflected in the prisons of all these little rooms. The forced physical incarceration is also psychological imprisonment in the past: memories of isolation, in which the world was still robust and lives were lived fully in their ripe, sensual plenitude. It is in this diseased and decaying world that we find ourselves materially imprisoned throughout the course of Grover's play. It is a world that laments and licks at its wounds. The spectator has the choice of escaping, of exiting the game, as it were. She may choose to release herself from a single room that gets too claustrophobic, or from the totalizing imprisonment crafted by this performance.

Yet she remains, morbidly mesmerized by the unfolding nightmare. The characters remind her of wounded animals; they are specters whirling in a dislocated world, uprooted from cities of the past, unable to congregate or hear other voices, *assembling in isolation the fragments of times gone by.* In a way, they are just like her, confined as she is in her cubicle, imprisoned and transfixed by her own flat screen. If this is not an experience of shared corporeality, what is? How do we then understand the live and the virtual? We are in this *now* together, but are we *here*? In the same place? Where is that place, if our screens separate us materially and irrevocably?

The Last Poet is, if anything, puzzling. It is also elegiac and claustrophobic. It is a strange glitch in our experience of time. It desperately clings to the debris of the past, even as it hurls us into a nightmarish future. As spectators/players, we all have innumerable choices. But just as in a free market, we are all ultimately and effectively imprisoned.

What follows is an interview-based exploration of the themes, formal imperatives, techniques, and political motivations that shape *The Last Poet* as an experiment in cyber theater. The conversation, which developed through a series of virtual meetings between myself and Grover in the months between late 2021 and early 2022, is our attempt to understand what really happens during a cyber performance. How do we, as embodied spectators, relate to the here and now? Where, if anywhere, is *presence*? What is the specificity of embodied experience in a digital performance? How do we understand the materiality of the screen? What does it do to our bodies as spectators and performers? Our conversation also explores the molding and reshaping of space in such a performance, reflecting in parallel on the strange collapse of private and public spaces that the social experience of the pandemic has engendered. How do homes become theaters in a performance such as this? How do we experience space socially in the post-pandemic world of this virtual space, where, according to Grover, "the private" has almost entirely disappeared?

In our conversation we examine the processes that built the narratives and spaces in this performance. What kind of audience was envisioned in this making, and what would be the nature of their collective experience? How might we reconfigure the ideas of democracy and public space in these circumstances? What are the political and ethical implications of spectatorship in such a scenario? Most crucially, however, we attempt to analyze how the virus and its social implications have folded into the political reality of our times. Do the fragmentations

we experience in our daily lives resonate with the physical isolation forced upon us by the pandemic? How do we now understand our monadic existence and the collective experience of our singular bodies on static screens? How might performance reimagine a political collective in such a world? How might we reassemble in virtual isolation to imagine a more robust political future for ourselves and our communities? How can we look for and find our disappeared poets in this floating city? In places, I have interspersed within our conversation my subsequent reflections (*in italics*), which can be read as notes on an evolving dialogue that has not yet come to a close. Or as a third voice that subtitles what is said by pushing it forward, toward other conjunctures: past and future. As Grover and I agreed at the end of our sessions, much like the floating city in *The Last Poet*, this is an ever-expanding exchange that promises to proliferate in directions beyond our immediate reach. Against finitude and closure, then, this is a conversation on storytellers in an arrested city.

The Conversation

> *Familiar though his name may be to us, the storyteller in his living immediacy is by no means a present force. He has already become something remote from us and something that is getting even more distant. [...] It is as if something that seemed inalienable to us, the securest among our possessions, were taken from us: the ability to exchange experiences.*

—Walter Benjamin, "The Storyteller: Reflections on the Works of Nikolai Leskov"

The Script
TNB: I wanted to know about the process of making the script. How closed or finished was it when you began rehearsals?

AG: The performers did not add a single word, actually, to the script. I was not looking for performers to add to the text in any way, but to do other things. The writer, Sarah Mariam, and I worked very closely on the script. She has been working with me for the last three years and has written for three of my pieces so far. We work incredibly exhaustively together when dramatizing a text or writing something afresh. A large part of the script of *The Last Poet* was, in fact, sourced from Sarah's personal memories and associations. For example, we spoke

of what [Saadat Hasan] Manto had said in the court during his obscenity trial. What I highlighted there were his mannerisms, his presence in the court while his case was being heard. We also read about Faiz Ahmad Faiz and Bashir Badr's cases. We read about how a writer was once picked up by the police from his house to be taken to jail and slowly the entire town began to follow the police jeep. By the time the jeep reached prison, the entire town was at the gate to say goodbye to the poet and to reassure him that they would be there when he was released. So, it was incidents like these that helped us to think about solidarity and about the relationship that readers have with writers. We also interviewed people who knew Sudha Bharadwaj, for example. We knew that the kind of writing she was doing annoyed the people in power. The speeches that were given at the gatherings she went to were interpreted in a certain way by the state. The false charges against her came thereafter. We did a lot of historical research and then some contemporary research. Varavara Rao, of course, was an inspiration. We got hold of the translations of his poems and read them together. We started to base the figure of this poet on the accumulated inspiration from all the different writers who we were reading about—not just contemporary writers but also older writers and poets. We were seeing how government after government, state after state, was afraid of the word. These incarcerations have been a way to discourage and threaten artists and writers for at least the last one hundred years.

This kind of research gave us the perspective to zoom out of the extremely distressing time we were in last year and to then think about writing a sort of epic. A very small one, but an epic nonetheless, in which there were multiple characters. I was not interested in developing a scene-by-scene narrative of how an event unfolds. I was interested in imagining a dystopic, strange city in which the story of a person exists only in fragments, in shards. So, as you walk through the strange city like a stranger you keep collecting bits and pieces from here and there. But you never actually come to a final, true story, but versions and versions. Some are truer than the others.

It was also about the way in which we were accessing the archives. We always access the archives with obedience, you know, with a kind of reverence. But it's impossible to tell which part of the archive is truer than the other. I was very aware of this. For example, we read versions of the same incident that took place between Ismat Chughtai and Manto in Chughtai's words and Manto's words. And they were dramatically different. That, for me, was key. I sat down with Sarah one day, I remember,

and I said: "Look, what if the whole piece is about the poet having disappeared? And we don't know what has led to his disappearance!" So, when we enter this dramatic fiction, it has just been a few days since his disappearance and everybody is speculating. And they are speculating according to the information they have. The ex-wife speculates in one way, the student in another, and the longtime friend speculates in another kind of way. They all imagine differently the kind of fate he might have met. And these characters never meet each other in the present. They have met each other in the past, they talk about each other. But now, they are *arrested*, just like our condition was last year: *we were arrested*.

> *Listening to the interview later, I think a lot about the word "arrest." I think about what the pandemic has done to that word and our relationship to it. I think of being arrested in the middle of a movement or a sentence: frozen, as it were, in time. A halt, a pause, a frozen screen, the wi-fi dropped. I am arrested in space. The screen grabs me, fixes me, I am in a frame. I think of incarceration. Self-isolation. House arrest. I am arrested in my room and have been for a while. I am disallowed from leaving, placed in isolation, having given consent to this arresting of the self by the self for the self. I am in my house, arrested. The house arrests me.*
> *Time and space are in pause. Nothing moves. Or everything moves very slowly.*
> *I float from one day to the next.*
> *News floats in that Stan Swamy has not been given a sipper in prison to drink his water. It is more than a year in prison for Umar Khalid.*
> *This too shall pass.*
> *But, for now, we are arrested.*

AG: The poet's disappearance then became the central event or the anchor around which the whole piece started to develop. We were trying to build a web of a narrative. Not so much a linear narrative that goes from point A to B, but a web. There is the sense that *you are crawling horizontally across a narrative* and not really progressing in time from one incident to another. So, this never gets completed.

> *I think of tapestries and carpets where ballad-like tales get told endlessly, in a weave that moves bewilderingly, disallowing linear perception. You could begin and end anywhere, catch a glimpse but never the whole picture at*

one glance.
Totality eludes you.
I think of the life of the Buddha narrated in traditional Tibetan
thanka paintings. It is hard to tell where to begin reading the
chronicle in its visual form.
The legend spreads everywhere.
It is circular and endless.
I think of the miniaturist painters in Orhan Pamuk's My Name
Is Red, *who are allowed to paint only one section of a*
spectacular work of art at a time in order to avoid the wrath
of the fundamentalists on a rampage.

AG: It had then become like *conducting an orchestra of characters*
where all these different characters were speaking in different
voices. By the time it was finished, I was happy with the balance
of this orchestra. That was when the whole script was given to
the actors and I requested them to not change a single word,
because it was written with so much care. But each actor was
free to visualize and imagine the character who was speaking.
All the characters you see in the piece are actually developed
by the actors themselves. Those characters—the way they
appear to you visually—are not necessarily written like that. It
was only the text, and the actors were free to develop it in any
way they liked.

The Camera
TNB: The notion that the camera is a kind of voyeur is by now
a commonplace of film theory, especially feminist film theory.
And true enough. Often, the camera does seem to have a kind
of authoritative gaze that can both control and intrude. Here,
however, *the performer, who is creating the character, is in
control of both revealing and refusing to reveal.* This, in a sense,
ties in with the fragmentary, anecdotal nature of the anti-narrative
that the performance gives us. My question is that this must
have been sensed and worked out in different ways by different
performers. Did you make an attempt to hold or tie together what
their relationship to the camera would be, for each individual
person? Did you try to have a kind of overarching politics of this?
Or did you just let things flower in the way they were naturally?

AG: Unlike the film camera, which has weight and volume—
a hulking monster ever-present on set—everybody was
performing for the web-camera or the camera in their phones.
The relationship with this small dot is very different to that
with the traditional camera. If, in the middle of our interview,

there was a professional Sony S-3 camera with boom mics, etc., our bodies would change. This kind of digital technology is less masculine in a sense; its presence is softer, it's not that intrusive in the way in which the film camera is. The way we are streaming ourselves today is markedly different from anything that has come before. Also, when we stream ourselves, we can watch ourselves, unlike when we are being shot. There is a feedback loop that is completed in that I can watch myself right now. I am in control of how much of my body I am revealing, what my background is like, how I am placing myself in the frame, etc. Plus, the device I am streaming with is my personal device. So, you are in my personal space a little bit and vice versa. Part of me is right now in your room. This kind of streaming is very different from anything traditional film does. We have to understand this on entirely new terms and on a very different ground. Comparative analogies with film, in my view, will not be productive.

Digitality is layered. For example, when we rehearsed as a group, we always had the sense that the person who was improvising a scene and looking into the camera was looking directly at me. But that was not true. This was an illusion, because that person was simultaneously on several screens and several people seemed to have the sense that they were being looked at by this person in a very intimate way. So, there is a multiplication that is happening: *a single moment of intimacy is being multiplied across a network* for hundreds and hundreds of viewers. I began to understand this as a kind of *hyper-intimacy, which is a kind of absent presence.* I can't hold or touch or smell someone, and yet they are present. *It's the kind of presence we used to associate with ghosts*: a kind of spectral presence where you always keep feeling that someone is around. When you see apparitions who you never actually meet. Digitality is that kind of an apparition. It seems to be present all around you: in your pocket, in your hand, on your mobile phone in a very, very hyper-intimate way.

In speaking about Frida Kahlo's paintings in her book When Was Modernism? *Geeta Kapur compares Kahlo's self-representation to the iconography in the popular Mexican art of the ex-voto or retablo. Retablos depicted martyred saints or the Virgin Mary on small strips of tin and wood in three tiers, and often included a personal prayer that devotees could carry with them at all times: in their hand, in a pocket or a bag. A ghostly but intimate presence: both quotidian and deeply spiritual.*

AG: And yet it is built on extremely fragile underwater cables that are laid across the globe. Much more than just the relationship of the camera and the performer, it was this disseminated presence that I was thinking about a lot. As a director, when I was watching these actors develop their pieces individually and collectively, I also had to imagine the conditions within which audiences will be watching them: the fact that it won't be on the stage—in the spotlight—where everything, the entire environment, is under the control of this created fiction and the audience sits in the dark. This was a performance that was going to take place in domestic spaces with much else happening around. That dictated a lot about the pace of the speech, the way the bodies would perform, etc. For example, there are many times in *The Last Poet* when nothing happens. They just sit. Or they just get up and change a light or something. To most film directors, that is wasted footage.

> "Pickling"
> *[performance] iz trying to find an equation*
> *for time* saved/saving *time*
> *but theatre/experience/performing/*
> *being/living etc. is all about*
> spending *time. No equation or ...?*
> *Suzan-Lori Parks (1995),*
> *Quoted by Rebecca Schneider in her essay*
> *"Archives Performance Remains"*

AG: They would say: "Why are you doing this? We need to keep a hundred percent attention on the screen." Whereas I kept imagining that my audience is only going to be partly attentive to the piece. I had the sense that the *energy of this piece somehow needs to leak beyond the confines of the screen* into other things around it. The audience might choose to look away and hear what's going on. They might get thrown out, the internet connection might break, and when they come back they shouldn't feel like they have lost something, missed something. They should be able to think of it as a wave that is taking place, rising and falling, over and over again. For me it was very important to slow time down, like really, really slow time down, to zoom in on the everyday, you know. How do we fold our clothes? How do we comb our hair? How do we apply an eyeliner or kajal or a lipstick? And to do it in a way that it is not preparation for something, but it is what it is. These small, nonverbal ways of being made the performance. It was important for every performer to understand that what they are doing in their isolation, in front of a small webcam, is part of a larger imagination, this virtual set-up. We

had shows in which each actor would step out of the show and just watch the show, for them to get a sense of what they were part of, because it was difficult for them to visualize it. It's also impossible for me to watch the entire show. I have never watched the entire show.

I wonder how incompleteness gets written into the very structure of this piece. Each spectator can access only a fragment. Totalities are forbidden. There is no "complete experience," no satiation, no possibility of consuming every word, every body, every glance, every gesture. No totalizing perspective finds a place anywhere. No person is omniscient. There are always missed encounters. Or perhaps we could think of an infinite number of possibilities? Of meetings and hyper-intimacies waiting to happen? Then there is the algorithm to think of. What does it know that we do not?

A Month Later

Amitesh and I have both had COVID in the interim, the third wave of the pandemic having hit both Kolkata and Delhi in the meantime.

The Algorithm, the Code, the Audience
TNB: I listened yesterday again to our whole conversation and there are certain words and phrases that have stuck with me. I want to ask you about them. But first perhaps we should talk about the algorithm—like you said, because we didn't get a chance to talk about that last time.

AG: I forgot to mention entirely about the algorithm. It was a two-month-long phase where we were developing the web portal and the entire software around it. I have been interested in the political understanding of algorithms and what software or an interface does. A lot of it, of course, is out in the public realm now. We know that interfaces affect our behavior in explicit ways and they drive us toward making certain kinds of choices. So, no interface is neutral or innocent, you know. Every interface that an artist or a digital company builds is riddled with biases and prejudices, certain ways in which it makes people perform and interact with each other. That was a key concern while I was building this with the coders. The first thing was to try to understand the kind of code they were building, to at least get the contours and the general rules. In code language, there are

two kinds of codes. One is the regular linear code. It performs a certain set of actions depending on how users interact with it. The other kind is nonlinear: what is also called a generative code. When you are writing this kind of code, you are actually not designing an interface. You are just writing a set of rules that will keep generating its own universe, depending on how people behave in it. Very early on we decided to go with the generative code.

TNB: So, this is not predictable like linear code? It develops much more organically? Can we use that word in this case?

AG: We let the code make decisions in the middle of the show, in that there is no human artist or director or coder sitting there making the decisions or controlling the show while the show is going on. The code now has dozens and dozens of rules. It keeps referring to those rules to generate more code and in order to choreograph audience movement. I chose this for two reasons. One is that it is only in generative code that the performativity of the code is foregrounded. Every interface performs. This is something I have been terribly interested in. *Digital code and digital interfaces often work through performance, actually. If we think of performance not just as an idea centered on the human body but in its more expanded field, this seems conceivable. We need to see that the key principles are there. For example, it is making decisions live, i.e., in the here and now; many of its futures are unpredictable (we don't know which way it will go); and it is in some way autonomous, i.e., it is making its own decisions as it is going along. All interfaces have this.* In fact, the biggest problem that Google and Facebook are facing with their algorithm is that they can't seem to control it. I heard the testimony that Google gave at a court in the Netherlands in 2020. They were asked if they could address the bias present in the Google search engine. Google claims that its predictive search is determined by the popular search options, which are often problematic. In predicting what you might be searching for, the interface is getting ahead of you, and in doing so [it's] also shaping the way you think or the way you might ask that question. Even if you didn't want to ask the question in that way to begin with, it might push you in that direction. So, in the court in the Netherlands, when Google was pulled up for this, they said that they don't know how to remove the bias. Even if they wanted to, they couldn't, because they don't know how it is doing this. The algorithm in the software is so huge now, and so many people are working on it, that it is impossible for us to tell you what Google will throw up in its search

engine, in which part of the world, at what time. And no one would believe it. The courts didn't believe it. But it's actually true. No one is in control of these massive interfaces anymore. So, we are living in a world where interfaces are already their own autonomous beings. It is impossible to intervene even on the part of the companies that made them.

All these questions were coming to me when we were designing the code. How difficult or complex should we make this code? Should we make it simple enough so that we can keep intervening? Or should we keep on making it more complex and layered, and at one point completely lose control of it? We have been walking that tightrope. We are on the edge of losing control of the software because now it runs into thousands of lines of code. It is no longer possible to make any change in it without affecting other things. So now it is properly its own beast. Anyhow, the first reason I chose generative software is that I wanted the performativity of the interface to be foregrounded. And I wanted every member of the audience to have a unique experience, depending on how long you stayed in a room, how you moved across it, etc. So, it will keep throwing different options at you. The other reason was that I wanted this interface to be very clearly democratic and I wanted to build those rules into the interface. One such rule was that the software would divide the audience equally across all performers at all times throughout the show. If one performer already had twenty people and the other performer had only ten it would keep sending the audience to the room that had a fewer number till the numbers were roundabout equal. Then it would choose another room. So, the interface is making these real-time calculations in order to organize and distribute the audience equally across the rooms throughout the show, so that everyone gets as diverse an experience as possible of the show.

TNB: This is interesting to me. As a spectator, I thought that I was making all the choices myself. That I was absolutely autonomous and this was all arbitrary. It was chance that was leading me through the space in a certain way. So I wasn't in fact making these choices all on my own?

AG: No. You weren't autonomous entirely. One is never autonomous when one is dealing with the internet. There is always a set of rules and codes that are, in an invisible way, governing and affecting our choices. So as a corollary to this first rule, you could imagine *The Last Poet* done in a physical space. Once the room fills up to its maximum capacity, in that case, you

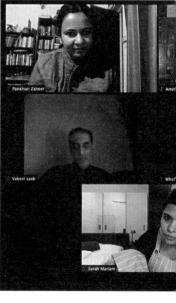

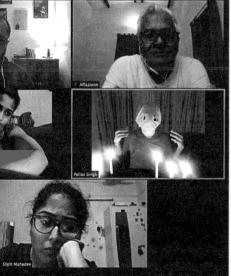

Screenshots of Zoom meetings, rehearsals, and work in progress of the cyber-theater project *The Last Poet*. The show premiered at Serendipity Arts Virtual, an online arts and performance festival commissioned by Serendipity Arts Foundation, December 2020.

Concept and Direction: Amitesh Grover; Writer: Sarah Mariam; Scenography and Technical Design: Ajaibghar; Films: Annette Jacob; Creative Technical: Praveen Sinha and Gagandeep Singh; Sound: Suvani Suri and Abhishek Mathur; Cast: Atul Kumar, Ashwath Bhatt, Bhagyashree Tarke, Pallav Singh, Dipti Mahadev.

can't enter that room. You are ushered into another room. The second rule was that the software, very subtly, performs two kinds of nudges. If an audience member is not moving at all and wants to watch only one performer doing several characters through the show, the software will start showing the option of leaving the room more frequently. If someone is moving from one room to the other too frequently, then it will try to nudge them into staying in the same room longer. So it's making a log—a secret log—of how every person in the audience is watching, how quickly they are moving, or if they are not moving at all, and these logs are visible to us in the control center we have built. This is interesting because I saw that audience behaviors changed. Some people tried to resist and not click on the "leave" button. With others, I could clearly see their behavior changing: they were slow in the beginning but they were going from one room to another fairly quickly toward the end. Then there were others who, having moved quite restlessly in the beginning, would select their room and then refuse to budge.

This made me realize that I could feel the audience. I could feel how they were moving, and I could feel their decisions. In some shows the audience was enthusiastic, and in others they were a bit lazy. I have often been asked how I got a sense of the audience in a digital show. I have always said that there were these alternate ways in which I could feel them. In our post-show discussions, we would find that the coders and the actors and everyone else has been able to feel the audience. This is something I was not expecting. This sense of the audience was transported to us through the code and through the logs, without us ever having seen any of the audience members. This also revealed to me the power of the interface. We talk so often about big data and how the big companies seem to know everything about us, they predict what we would like to buy next and where we would like to buy it from, etc. I got a peek into how powerful this kind of data collection is by itself. That scares me a bit—if we could do this for a theater show, what could these companies be doing with massive amounts of data and exponential quantities of intelligence, human resource, and infrastructure? I often think critically about this: how much more could we have done?

TNB: Oddly enough, we have the sense of a certain kind of anonymity in the digital space. Even though we know that that's not how it works, there is still a persistent sense that we are both anonymous and free. I felt, for example, in watching the play that I was unseen, my face and my identity were mine only, but all of the time the interface was building an identity for me. I did have a history so far as the interface was concerned. This is interesting,

because this was not the sense with which I watched the show. At least when you walk into a physical performance space you know that you are being seen. But here you have the clear and present sense that you are anonymous, but you are in fact not so.

AG: I wouldn't say that your anonymity is being diminished somehow, but you are certainly being tracked.

TNB: No, not in terms of your identity *per se*, but perhaps in the sense of things that might be more intimate: like the mood, your energy, whether you are conservative in your choices— you like to stay in one place, or are you restless? These might be, in certain circumstances, far more intimate questions than what your surname might be or what you might be wearing at that point in time. These are closer, right? So then how are these assessments about the audience, in your view, different from what you would have done in a physical show, where you have proximity?

AG: The actors keep seeing the viewers in terms of numbers. They know how the numbers are going up and down. If twenty comes down to five, that has a really visceral impact on the performer. This kind of physical affect is coming from livestreaming cultures. Every performer who is on Twitch, for example, whether they are gaming performers or erotic performers, they are very aware that they are being watched and how many people are watching them. The chat section is even more revealing, in terms of what kinds of comments people are leaving behind. So, the physical and the digital are not in opposition anymore, where the physical has a heightened sense of the presence of others and how they are behaving and the digital does not. I would say that they are far closer to each other today than they were, say, a decade back. There are ways in which code and different instruments help us translate the moves, the behaviors of people online into something that can be understood and felt on the other side.

The Arrested Epic
TNB: I want to now move from this a little bit and pick up on two words you used in the interview the last time. I wanted to ask you to comment on them a little further. Toward the beginning you said: "I think about this production as an epic with many voices and many characters." I want you to elaborate a little on why you say "epic." You go on, then, to talk about how the play picks up at a point where the poet has just disappeared and the

speculations begin thereafter. The epic, as we know, begins in the middle of the action. Is it a depiction of a linear set of events, then? Or does the epic involve a different imagination of time? That's one question.

The other is also to do with time. You said at one point that "We are all arrested." You used that word today as well. It keeps coming back. At one level, it seems like wordplay, because arrest features in a different way in the narrative as well. Then, because of the pandemic, we are all arrested in our different cubicles. The experience of watching the piece is also another kind of arrest. Then again, time is arrested, oddly enough. This is not meant to be a scholarly or even analytical question. But just as an artist who was building a world in making *The Last Poet*, if you could comment on these two words that you used and what their resonance is to you.

AG: I am really happy that you brought these two words back. They feature in a very significant way. They kept coming back to me—both these words and ideas—throughout the making of *The Last Poet* and even afterward. I remember describing my intentions to my dramaturge when she began writing it. I said, "Think of it as the writing of a very small epic." She asked, "What does that mean?" I said, "It starts bang in the middle of something and it doesn't have an ending." I have been to Ramnagar ki Ramlila a couple of times and that left a significant impact on me. No theater has ever been able to match that. It's a thirty-day immersion in this performance. I don't know if you have read Anuradha Kapur's book on it ...

TNB: I have.

AG: So that thesis describes the Ramlila very accurately. It's an immersion into a real town but the town changes because of the different scenes that are played there. What's very interesting is that there is hardly any acting happening there. The whole epic is being performed but there are no actors, because all the actors who are playing godly characters are preteens. Once you hit puberty you are not allowed to play Ram or Laxman. It is impossible for these preteens to learn the verse. If they can't learn the verse, they cannot act. Valmiki, one of the pundits, keeps his *Ramayan* always open and he keeps whispering the verse into their ears. And then they repeat it. That changed for me the whole idea of what theater was, what performance was! This whole notion that the illusion must be built in the theater for it to be effective, etc., it all came crumbling down for me. When I came back from watching the Ramlila in Ramnagar for the first time, I

decided that I wanted to keep working around it in my theater. I don't want to do realistic plays; I don't want to do psychological plays. I just really want to understand the nature of this epic and the performance of this epic, which affected me so much. How can I search for it and keep looking for it in my work?

There are two or three things that *The Last Poet* was built on in terms of its dramaturgy and its structure. The first was that it did not have a beginning or an end. It could actually go on for two or three more hours. In the conceptual stage, even in my proposal, I wanted it to go on for a month without a break and I wanted to cast a hundred people. One set would start the work, then a second would take it on, then the first would go away. It would just be wave after wave after wave of performance that everybody could watch. The second thing is that the piece is infinitely expandable. At one point, my dramaturge just got exhausted and said, "I can't write any more characters." I said, "Well, if you can't write any more characters, then that's the border of this. Now this is our script." But if she had written more there would have been more characters. It is like an expandable entity. The epic is not focused on a single narrative or a single character. It is expandable in terms of its dramaturgy but also the world that it wants to talk about. The missing poet is a catalyst for as many people and voices to come into this world as possible. The third is, of course, the question of time. The epic is always happening in your time, unlike the theater of illusions, where you are transposed into the narrative's time, for example in period drama. Whereas the time of the epic performance is our contemporary time, which is why it needs to happen every year. The fact that it's happening in my time is extremely powerful for me. *The Last Poet* doesn't have any strong or visible period or era points in terms of costume, etc.

"Nishastgah"

In leafing through the material that I had gathered in preparation for writing this piece, I come upon a PDF file of a presentation about *The Last Poet*. I imagine that it might have been prepared during the project's initial conceptualization for Serendipity Arts Foundation, which had commissioned it. In this file, I find a quote that I finally trace back to an anthology called *Trickster City: Writings from the Belly of the Metropolis*. It reads:

> Finally, Shamsher offered his explanation: A place in "nishastgah" is a place where the gaze has not yet been fixed and time has not yet been disciplined, where nobody has yet been described as a "vagabond." When a place loses its "nishastgah," it condenses into a "jagah" (place).

By then it has moved through its processes of working out what it wants to remember and what it wants to forget, who wants to keep in and who wants to keep out, which ways of being it finds acceptable and which are the ways it shuns or tries to stay away from.

These words set off some sparks in my beginners'-level Farsi brain. I dig out my Farsi-to-English dictionary. This is what I find. "Nishastgah" translates to "sitting place": a place where you can rest for a while, literally any place that will allow you to catch your breath and rest your behind. A moving horse's back, a stone, a patch of grass on a field: anything could be "nishastgah." A moment of stillness in the midst of long and thirsty journeys. Perhaps a place willing to let you rest without containing you or fixing you. Or imprisoning you within its boundaries. It is your sitting that made it a place; your moving would let it go. Your decision to rest gave it its placeness. Your decision to walk away would dematerialize it.

Perhaps this is how we must imagine each room in *The Last Poet*: a resting place that disappears when your back is turned. Your presence completes it; your witnessing makes it material. It is in the reciprocal in-betweenness shared by the one seeking a rest between subsequent journeys and the storyteller who tells a tale in the interim that the *nishastgah* is created. No promise of fixity is advanced, no assurance of permanent habitation. You cannot live inside a story forever. A story is transient. It is also always being told anew, simultaneously, everywhere. It finds you before you find it. Planning will not get you there. A story is a resting place, and that only for a moment, until you find another story, or another story finds you swimming in its middle.

Perhaps that is what all cities should be: homes that let you rest, without arresting you. May our cities be resting places for our lost poets and storytellers.

Notes

1. Diana Taylor, "Save As … Knowledge and Transmission in the Age of Digital Technologies," *Imagining America* 7 (2010): https://imaginingamerica.org/wp-content/uploads/Foreseeable-Futures-10-Taylor.pdf.

2. Judith Butler, "Bodies in Alliance and the Politics of the Street," *Transversal Texts*, September 2011, https://transversal.at/transversal/1011/butler/en. This essay later became a chapter in Butler's book *Notes Toward a Performative Theory of Assembly* (Cambridge, MA: Harvard University Press, 2015).

3. "Amitesh Grover's *The Last Poet*," Ajaibghar, https://www.ajaibghar.com/our-work/the-last-poet.

4. Walter Benjamin, "The Storyteller: Reflections on the Work of Nikolai Leskov," in *Illuminations*, trans. Hannah Arendt (New York: Harcourt Brace & World, 1968).

5. Sudha Bharadwaj is an Indian trade-unionist, activist, and lawyer from Chhattisgarh, who is also popularly known as the "people's lawyer." She was arrested on August 28, 2018, in connection with the Bhima Koregaon/Elgar Parishad case.

6. Varavara Rao is an Indian activist, poet, and teacher. He was arrested in 2018 in connection with the Bhima Koregaon case.

7. Geeta Kapur, *When Was Modernism: Essays on Contemporary Cultural Practice in India* (New Delhi: Tulika Books, 2000).

8. Rebecca Schneider, "Archives Performance Remains," *Performance Research* 6, no. 2 (June 2001): 100–108.

9. Anuradha Kapur, *Actors, Pilgrims, Kings and Gods: The Ramlila of Ramnagar* (Calcutta: Seagull Books, 1990).

10. Francis Joseph Steingass, "Nishastgah," in *A Comprehensive Persian-English Dictionary, Digital Dictionaries of South Asia*, https://dsal.uchicago.edu/cgi-bin/app/steingass_query.py?qs=nishast-gah&matchtype=default.

11. Shveta Sarda, "Translator's Note," *Trickster City: Writings from the Belly of the Metropolis*, trans. Shveta Sarda (New Delhi: Penguin Books India, 2010), 311.

12. Debaroti Chakraborty foregrounds this wordplay in her review of *The Last Poet* in *The Telegraph*. See Debaroti Chakraborty, "Poetic Choice," *The Telegraph Online*, January 16, 2021, https://www.telegraphindia.com/culture/arts/review-the-last-poet-cyber-theatre-directed-by-amitesh-grover-written-by-sarah-mariam/cid/1803790.

DALIT ART

SURAJ YENGDE

What is the purpose of art? This question has baffled artists as much as art admirers and critics. I believe the purpose of art cannot be defined in simplistic terms. Art has an objective: to serve human emotions and vulnerability. More importantly, however, is its role in guiding human sensibility. It is a rendezvous of unexplored or repressed emotions that we have carried all along. Giving these emotions a chance, art provokes moments of reckoning and candid dialogue to testify to the post-time phase. Art allows us to surrender, to submit to a higher feeling— that elated moment of understanding.

Art is a feeling that comes to you unfiltered. Submitting to the command of art is the effect of an artist captivating your imagination. Artists are multilingual, and their tradition is universal; art can disrupt and create ruptures in the quotidian.

By elevating the unknown and the unexplored to an increasingly rationalizing mind, art can humanize faculties that are condemned to hospitals and clinics. The gap between consciousness and the unconscious can be filled with the artist's belief of a hope beyond the present. Art is also that enthralling alley that can create a sense of ecstasy that we otherwise seek in narcotics. A portrait can arouse waves of emotions in suppressed bones and allow us to grieve or celebrate. A performance onstage or a musical note, a poem rescued from the long-forgotten dust of scribbled lines, or the springtime Impressionist touch of Monet all invite us to witness the multiple moods of life. Herein lies the power-praxis of art's ontology.

Art has the potential to take the axioms of fear and vulnerability of an individual to the public, where interpersonal choices become appreciable. Feelings of insecurity give

way to moments of solidarity, diminishing the burden of shame and evoking the lightness of the moment. Human relaxation is momentary; we yearn to prolong the memory of this moment. Some follow a life of remembering the moment of this relief, of achievement or passion. That is how an interpretation of a "safe haven" is drawn through the many facets of human imagination.

My inspiration lies in the art of the Buddhist world and Post-Impressionism. Both can capture time as a snapshot within a galactic history. These schools of thought have delivered sermons of truth. It is no accident that art has constructed realities that even the most advanced technês have barely managed to touch. Vincent van Gogh's most famous artwork, *The Starry Night* (1889), depicted a version of the cosmos when Europe was still grappling with Galileo's and Leonardo da Vinci's estimation of the outer world.

Buddhist art exemplifies humanity's highest point of achievement. Each craft—carefully chosen, worked on, and delivered—reflects the mighty legacy of the Buddha's ancestral endowment and his immense compassion passed on through generations praying for Metta, the concept of universal kindness. This loving-kindness of all is articulated through the channels of spiritualism aided by art.

Buddhist Past, Dalit Present
Dalit Art is a moment and a school of thought that embraces the ancestors whose lifeworlds and personal stories define our present existence. The bold statements of Dalit artists and the affirmation of their wretched position are not to be discredited as cheap gimmickry. Within the Dalit art world, there is hardly an occasion that does not speak to the appalling social or political circumstances their community is forced into. Dalit artists bring to the fore the genius of their talent and merge it, like two massive flowing rivers, into their art genres. For example, Vikant Bhise's specialization in contemporary art evokes the intuitive nature of the Impressionists in masterful strokes. However, his trenchant take on his people's unjust, inhumane social conditions is palpable.

Art is a lived politics for Dalit artists.

With the advancement in techniques of visual mobility and strides in motion pictures, a more human-centered appeal has developed over the past century. Sometimes this appeal is manipulative. At other times, it is sincere. If cinematic exposure does not inculcate a feeling of insult, love, and contempt, it has not achieved its purpose. Cinema has an audience committed

to its complete vision. Within its focused time frame, it has a captive viewership committed of its message. With multiple tools and shared art practices, it has an opportunity to communicate many possibilities.

Dalit cinema crafted by Pa. Ranjith, Nagraj Manjule, Neeraj Ghaywan, Mari Selvaraj, and a host of other respected film-makers and producers from Dalit and oppressed communities has transformed the tag of caste into a badge of honor that pays respect to the artists' ancestors and contemporaries.

The enrichment of music, theater, painting, sculpture, rap, and dance as a Dalit art form is still in its twilight phase for the outside world. To illustrate the buried moral and ethical mandate in art, one needs to accept one's own culpability, and this becomes the defining feature of the art. To make sense of the emotional response attached to the artwork, one needs to deploy the philosophical necessity of aesthetics. By delving into the reason of art, we can open up to various meanings that address a host of human anxieties. Art is put to the test when it faces tyranny. Aesthetics allow emotions and belief to have meaning. This meaning can be generalized. Its value does not rely on the creator or the observer. The meaning here is a transliteration of the direct sensations experienced through mind and touch.

Here, I will focus on the creativity of modern expression manifested through the lyrical gospels of Dalit artists. It is about the expression, or cultivation, of the mother tongue in a rap song, its emphatic tone and raging enthusiasm simultaneously soothing the soul and agitating the mind. Dalit Art, in general, unites the mind by bringing together the sensibilities of anger and sorrow, and by speaking up without fear. This conversion into action demands accountability of life's worth. Waman Kardak, one of India's most profound Dalit poets, questioned the absence of anguish among the Dalit masses. Putting the burden of determining the cause of passivity back on himself, Kardak considers who he should blame for his evasive emotions.

The slaughterhouse and the Dalit home are next to each other. The burial ground and Dalit food coexist. The Dalit writers Sharankumar Limbale and Daya Pawar tell us about the inhumane conditions of rural and urban ghettos in which Dalits are forced to live. In the evening, when the father and mother come back from a hard day's work and put food made with salt and chilli powder on the table, the stench of the burning corpse in the cremation ground just outside the window wafts in. While consuming a hard-earned meal in the makeshift hut, the vulnerability of life condemned as the lowest of low doesn't leave the shadow of philosophical death.

One needs to go through the darkest chambers of fear, threat, and pain. Without sincere pain, it would be a challenge for art to penetrate people's hearts, and that connection would perhaps be fleeting and superficial.

Separation and pain are two steadfast foundations of art. The artist must separate from attachments to create a space for art. This separation can take many forms. But the artist must follow the route of pain not just as a felt emotion, but also as an ascriptive complexity containing a one-off metathesis. The route of pain is borne of a womb that was banished for generations, a forced exile—Dalit artists draw themselves out of this darkness, or makes darkness their theme to create new art.

Dalit art evolves into an organic osmosis of theory and praxis. However, for it to achieve a universal significance, it

Fig. 1 Prabhakar Kamble, *Broken Foot*, Wood, 6 x 6.5 inches (15.2 x 16.5 cm). 2020.

needs to bring the experiences of other oppressed peoples into its fold. The Harlem Renaissance, Cubism, and Negritude movements belong to a long tradition of foregrounding the humanity of the Black and Brown body. However, many Dalit artists who have been formally trained in schools, or by their elders, have taken the clouded and sunny terrain of these movements as an invaluable inheritance. Their mission is to make discomfort everyone's, rather than theirs alone.

Prabhakar Kamble (see Fig. 1) works in various media to make conventional norms uncomfortable. His portraits, sculptures, and performances depict the regular. Powdered pigments, pots, sculptures, bodies, and feet are his aesthetic collaborators. By presenting to us a broken foot, as he has

sculptured in his artworks, Kamble smashes the belief that this is natural by making it an issue of society. The foot cannot be elsewhere but at the bottom, giving balance to the rest of the body. But it is condemned as unholy and dirty. Kamble crushes the foot and smacks society on its face with the responsibility of standing tall.

Parallel Worlds in One Universe
The turmoil in the world has produced many reactions. This has allowed our true selves to be manipulated by external factors. Can unadulterated emotion be an act of performance? For, in the act of mimicry, one can truly expose one's true self. The search for the true self is impeded by the self-presentation demanded of us. We are constantly looking for the most accurate image, one that is unique to us. If something precious is accessible to all, its value compounds into the hybridity of experiences. Uniqueness counters the nature of exogamic art.

Dalit Art has a responsibility to correct the measures by other people that attack not just their own dignity, but that of other oppressed peoples. For, the enemy of Dalits is not theirs alone. The enemy's impulse to destroy the world is rooted in the nihilism of caste society. Thus, the artist needs to summon every tool possible to break the oppressor's chains of persecution.

Establishing a Standalone Shared Legacy
I have argued in *Caste Matters* (2019) that the contemporary era is an arrival of the Dalit Harlem moment. This proposition needs further clarification. The Dalit body and aesthetic are yet to be accepted as art by all. Yet Dalit artists have produced great art, be it performative, visual, or graphic. By exposing themselves to enormous risks and conducting bold experiments grounded in self-examination, Dalit artists also inform us about the practical exigencies in their daily lives. The life that is mediated by past traumas and resentments is constantly challenged by insecurities and creates an image of vulnerability and the capricious nature of love.

Dalit Art stands in opposition to the anti-Dalit, anti-humane forces. It is guarded against violence and oppression by its vision, which channels pain with a poetic touch, and from a fiery source.

Art as an outcome of boredom has a different value than art as a necessity. The Dalit artists who bring the energy of the past and the vulnerability of the present into the art they practice nourish the field of art. Artists from an oppressed

Fig. 2 Vikrant Bhise, *The Rise of Protests*.
Acrylic on canvas.13 x 11 inches (33 cm x 28 cm). 2021.

Fig. 3 Malvika Raj, *Sujata*. Acrylic on canvas,
30 x 20 inches (76.2 x 50.8 cm). 2013.

Fig. 4 Tejswani Narayan Sonawane, *Togetherness*, Etching on copper plate. 7 x 9 inches (17.8 x 22.8 cm). 2019.

community bring out the true nature of art as a protest culture and joyous experience. They do not believe in adulterations and cheap copies. By approaching art as a necessity, Dalit artists repatriate what was taken from them. The vastness of their imaginations are not easily diluted. One needs new tools of analysis and a refined language to gauge the possibilities of this limitless art against the sky of impossibilities.

Dalit Art is strong and soft. It relies on the audience to consider the conditions under which it was made, be it the symbolic gestures in Vikrant Bhise's paintings (see Fig. 2) or the calculated strokes of Malvika Raj's Madhubani art (see Fig. 3), which created waves by introducing a new subject to a centuries-old Hindu style of painting: scenes from the life of the Buddha. Tejswani Narayan Sonawane's Jataka-inspired works (see Fig. 4) represent Buddhist tales told through animals depicting a courageous sociopolitical movement against caste exploitation, while Rajyashri Goody's installation artwork (see Fig. 5) is a scathing commentary on untouchability. Manish Harijan's conceptual photo-performances explore notions of visibility and invisibility (see Fig. 6), while the embrace of the human and nonhuman ancestors in artist Sajan Mani's performance is an indictment of the caste system (see Fig. 7), and the donkey is a recurring theme in Ranjeeta Kumari's works

(see Fig. 8), with its history as a beast of burden. Like their Dalit compatriots, these artists put a permanent stamp of their uncompromising nature in the exclusionary space of caste culture. They produce strong statements through the radical and forceful languages of their art. Their ambition is not only to destabilize the pro-caste art sphere, but to create a space for Dalits to feel as though they belong. It is the quest to create a permanent home in the house of comforting wilderness that Dalit Art offers as a humanistic cover.

Pramod Ramteke is an Ambedkarite Buddhist from Nagpur who experimented with various art forms, ultimately validating his subjects and themes through philosophical theories on Dalit life. Ramteke received a retrospective titled *Open Mind* at the National Gallery of Modern Art in Mumbai in 2021, which include over 250 artworks. It was the first time that a Dalit artist was recognized in this way, and it took four years of lobbying and fending off aspersions. What does this veteran artist, who grew up in poverty but gained strength by internalizing Ambedkar's message of liberation and dignity, offer the general public? He provides the world with a unique opportunity to experience Dalit life.

Fig. 5 Rajyashri Goody, *What is the Caste of Water?*, 108 glass tumblers containing dried and diluted panchagavya (a mixture of cow dung, cow urine, milk, ghee, and curd), 2 plastic bottles with cow urine. 118 x 39.4 inches (300 x 100 cm). 2017.

Fig. 6 Manish Harijan, *Shaman (unseen Untouchable)*, C-print on aluminum, 38.7 x 56.8 inches (98.2 cm x 144.4 cm). UK Government Art Collection, Purchased from the artist March 2021, through the Art XUK project 2020-21. 2019.

This work was created to highlight the issue of statelessness and the importance of human rights for each individual. Manish Harijan contributed this piece in accompaniment to his performance art at the Museum of Communication at The Hague.

Solidarities of Emotions

Solidarity between anti-oppression movements and Dalits expand the possibilities for global futures in which creativity proliferates at protest sites. These sites of solidarity have always wandered into the world of art. Literature, visual art, and music have created possibilities for Dalit freedom in the minds and rhythms of world culture, through the plurality of Bollywood and classical Indian forms. To sit under a tree on a hot day, worn out by days of hard labor, and become mesmerized by a song that invites the soul to rejoice—this is absolutely necessary. The Dalit voice, crackling with pain and lament, invites everyone to participate in the grief and contribute their tears as alms.

Dalit musical performers are original and unfiltered. Their music will affect you only if you're willing to submit to the unseen. The spirit of Ambedkar is called by the performer. Ambedkar's energy and guidance works its way through the performer and the audience. Ambedkar comes to you, sits with you, and leaves you with a heightened feeling of relaxation. He inspires you to wrap up your rug and go home to think about the kind of world you want to give your children.

Late at night, while staring at the tin roof and darkened wood that supports the house's structure, you imagine an impossibility—what to do with your life? The answer comes as enlightenment: prepare the next generation. They must be like Ambedkar. They need to carry his work forward. *The children need to dress like him, speak and write like him. I need an Ambedkar in my house.* Revolution is born in parents that night who vow to educate their children until they become Ambedkar. The spirit of Ambedkar never dies in the performance. In moments of sadness, Ambedkar appears like a force and works much like he did at the performance many nights ago.

Harsh measures of justice need a sharp vision with a focal point. Dalit Art is a timely theme to address this. The artists' might comes from an enduring preoccupation with their subject, and from its need to be expressed, shared, and communicated in unison among the artist, viewer, and critic. Art is a spiritual experience for Dalits, through which they convey love to the Supreme and consciously care for the vulnerable. The purity of inner feeling is expressed through the compassionate embrace of new innovations formed within the sublime imagination of the artist. Dalit Art reflects the Buddhist tenet of recognizing the self as changing materiality. The political and sensual join to revive the human spirit.

The floating surface of water adapts to nature's ever-changing forms and colors. It allows for nature to reveal itself comfortably,

Fig. 7 Sajan Mani, *Caste-pital*, performance still. From the Specters of Communism: A Festival on the Revolutionary Century, conceptualized by Okwui Enwezor, curated by Raqs Media Collective. Haus der Kunst, Munich, Germany. 2017.

Fig. 8 Ranjeeta Kumari, *Beast of Burden*, Donkey series, Watercolor on paper. 9 x 12 inches (22.8 x 30.5 cm). 2020.

without prejudice, and identify itself clearly. It is the first glimpse of a deeper story that is unexplored. Dalit Art is a door to that surface of nature that can be understood through the minds and bodies of the Dalit touch. A critical assessment of the world that has not yet developed a grammar to accommodate the viewpoint of the vulnerable margins, Dalit Art is evidence of that testimony. Dalit Art is a refuge of the undesired and the unspeakable. Thus, like the temporarily unchanging surface of the water, Dalit Art is a space for the indeterminate willing to take the risk to determine its position. The constituency of the banished is preparing to establish its kingdom. Dalit Art is an ancillary guide to a present and future council of thinkers and practitioners.

TOUCH

HOW TO LEAVE A HUSBAND

JEET THAYIL

He went online and bought round-trip tickets, Algeciras-Tangiers-Algeciras, and arranged a day trip from Tangiers to Chefchaouen in the mountains. They'd return to Algeciras by the last ferry. She already knew it would be a rushed, anxious trip and she didn't want to go. She wanted to explore Tangiers, the port town she'd read about and never imagined she would visit. But her husband wanted a *tour*. He wanted to be guided, to be part of a group and see the sights. That wasn't the worst of it. The incomparable worst was the way he reduced a place to sound bites taken from the internet, factoids that killed any mystery a city might hold.

- Everything is blue, he said, the whole city, even the
 flowerpots and streets. Can you imagine?
- Um, yes.
- Built in the 1400s and painted blue five hundred years
 later. It symbolizes God looking down upon the earth and
 painting his colors on all that he sees. That's why the
 roofs are blue.
- If God's color is blue, why ...
- The streets and walls and houses, a brilliant blue.
 Symbols!
- How much do you think we'll see in one afternoon?
- Enough. They wouldn't offer a tour otherwise. It's only a
 two-hour drive from Tangiers up into the mountains of Rif.
- How much will we see of Tangiers if it's a two-hour trip
 back?
- Oh, enough, enough.
- Is it painted blue to symbolize a love of tourist dollars?

It was his interest in travel—and his admiration of her posts as an influencer—that had made her accept his parents' proposal, even if there had been red flags at the very first conversation. Their respective families had left them alone in the living room. They talked about Ladakh, how it was snowed in all year round and accessible only during the summer months. Imagine going in the good weather and staying until the roads cleared eight months later, she'd said, what an experience! His face had registered not delight but horror. Chachiamma ignored the flag, the *tiny* flag, but she should have known. And now here they were, on a ferry from Europe to Africa, on the deck looking for photo opportunities.

> – There might be whales too, he said, talk about
> maximizing one's Morocco experience!

His mouth set into the shape it took when he was determined, curving downward as he turned in a tight arc to take panorama pictures on his phone. Of what? Perhaps he really believed a lost blue whale would surface for his camera. She prayed nothing would show, no dolphin or flying fish, not a single one of God's good sea creatures. Please don't, she said to herself. It was an uncharitable prayer, but she had her reasons. What she liked most about travel was the act of travel, being somewhere unreachable where no one would find her. She'd take a picture and post it and that was that. She was gone. Now, all had changed. Her husband posted several times a day, tagging their location, each bar and restaurant and bus station and airport, all on his feed for everyone to see. She was no longer off the grid but pinned to it. She was of the grid. Another pin on a vast map of pins, watched, triangulated, remarked upon, known at all times. She tasted salt and watched the churn left by the ferry as Spain receded behind a veil of spray, each drop an element in a pattern of disappointment. The dress she'd worn on the flight to Madrid felt stale against her skin, as if it had accumulated a layer of grit inside the fabric. She went to find a restroom.

At the metal staircase leading to the levels below were half a dozen people listening to a tour guide, a woman with a cane whose eyes were hidden behind impenetrable dark glasses. The woman didn't sound like any tour guide she had ever heard and her audience wasn't paying much

attention. We are all different, the woman said, that's what they tell you. But are we really? And if so, how so? I hear a question quite often these days, people asking each other, where are you from? The replies are one or two words that are always inaccurate. Nobody is from one place, and where we are really from is where we're going now, Africa. The body of water we are traversing wasn't always here. It appeared after Europe broke off from the mother continent. By this I mean a very simple thing: this journey, this ferry, is a return, and it might be the single most important journey you will make. Here the woman paused and the people who were listening looked at each other, at the sky, at the brilliant water, and some of them wandered away to take pictures of the ocean. She said, like the Suez Canal, this is a mental water body more than a physical one, to separate Africa from Asia and Europe. It underlines the fact that we are not different but connected. The origin story of mankind says that we, our species, descended from a hominid group that lived in Africa some two hundred and fifty thousand years ago. Some said East Africa, others South Africa, but always they pointed to one spot, usually Botswana, as the cradle of the human race.

Chachiamma strained to hear, alone above the noise of the ferry, as the soft pulse of the blind woman's voice drew her close. She tried to be inconspicuous but the others in the group had noticed her. They looked at her blandly, without reproach, faces impassive, even bored, as if they had no inkling how extraordinary were the woman's words. Last year, the woman said, some fossils were found in Morocco, inside a cave called Jebel Irhoud, not far from where this ferry will dock. The bones were more than three hundred thousand years old, the oldest fossils of our species ever found. So now, they say, we must add a new region to the cradle theory: northwest Africa, the exact spot we are approaching. Why should these theories be in conflict with one other? Isn't it possible that there were representatives of Homo sapiens in different parts of the continent we now know as Africa? That there were groups of early humans who would meet and mate, exchange blood and weapons, DNA, ideas, and then pull apart for whatever reason, say climate, or hunger? That humans have been subject to a jumble of accidents called evolution by some, although it may be little more than the pinpricks of a procreation theory? The more she spoke, the more Chachiamma was

determined to stay within earshot. What she was saying applied to everyone, but especially to her, Chachiamma. I am blind, said the woman, which means I'm less prone to the sway of appearance, eye color, skin color, hair texture, body type, all those things you set so much stock by. Here she paused and lifted her face and nodded. Now, she said, may I have two volunteers? Chachiamma put her hand in the air without meaning to, then, realizing the woman could not see, she said, I volunteer. Who else? said the blind woman. Me, said the man closest to her, a scruffy old man with gray-blond hair. Someone take my cane, said the woman. She placed a hand on each of their faces. I can guess that you are a woman and you are not, she said. I can guess that you both have two eyes, well-shaped skulls, prominent jaws, and smaller faces than, say, Homo erectus. Other than that, I can only say that you are very similar. Chachiamma looked out at the water but soon enough her gaze returned to the woman, whose hand stayed on her cheek. And now I want to talk about dogs, the woman said, reclaiming her cane and tapping twice on the deck. Look at the enormous range within the basic motif, how different they are, in size, in temperament, in shape and purpose. I compare dogs to humans and I am struck once again at how similar we are. It should be clear that our differences are of color, more than shape and size. But wait, the boat's slowing, we're coming into dock. I will continue my lecture on the return journey, if any of you are here then. In the meanwhile, I wish you a pleasant visit to Tangiers. When the boat docked, Chachiamma knew exactly what to tell her husband, who was still on deck, waiting for dolphins. She said her period was upon her and she could not accompany him. She'd stay on the ferry and meet him at the hotel in Algeciras. Her husband was always uncomfortable at any talk of a woman's period, so much so that his faculties seemed to shut down. She was surprised by how amenable he was to the idea of going on the day trip alone: he might even have been relieved.

On the return journey, the woman spoke about borders, how important they were for a nation's sense of its identity, how fragile was that identity, and why it was that fraternal or neighboring areas had a more contentious relationship than those that were far away from each other, Israel and Palestine for instance, or Pakistan and India, or China and Japan. It wasn't territorial rivalry these countries were

engaged in, but an imagined battle for survival. The woman took a seat and seemed more relaxed now. Her audience had thinned to three people. Chachiamma sat beside her and as she listened she felt comforted for the first time in days. She stopped hearing the meaning of the words: she heard only cadence and pitch. When the woman announced a lunch break and got up to go to the bar, Chachiamma followed. The blind woman counted her steps, expertly using her cane to gauge space. She moved more confidently than the people around her, and Chachiamma wondered whether she was really blind. As soon as the woman took a seat near a large window that looked out on a sea turned slate and choppy, the waiter brought her a glass of wine. Chachiamma asked if she could join her. I heard your lectures, she said. The woman didn't reply, but took a sip of her wine and sighed, then said, reluctantly, you may sit. Chachiamma blurted out her question. Do you need an assistant, or a researcher, photographer, anything at all? I'd be happy to help. Silently, she said, please, please say yes.

- No, said the woman. I'm in no need of assistance.
- Oh, I don't mean you need assistance, I can see you don't, it's just that I found your talk useful and...
- Useful? Of all things, why useful?
- I don't know.
- I'm of no use, not to you, not to anyone.
- I just want to help.
- If you really want to help, leave me alone.

The blind woman's head swung from side to side, as if she were being slapped. But she didn't get up and she didn't ask Chachiamma to leave. The ferryboat rocked a little, buffeted by small waves the wind had picked up. The woman's expression was so alert it made Chachiamma's skin prickle. She got up and went to the restroom where she splashed water on her face and examined her eyes. She saw the green tracery of veins under the skin of the eyelids, the hard-working eyebrows, the lashes that protected the eye's delicate tissues from dust. She saw that her arms were extensions of her eyes, and her fingers, how fragile they were, and necessary. Inside her she saw the cisterns and viaducts of a city, and the nature of the lie she told her husband struck her anew, for she saw her baby's new heartbeat coming into a steady rhythm. To be with child at such a time, by such a man: what a feat of bad judgment,

impossible to undo. She shook out a cigarette and remembered she was pregnant and tossed the pack into a trashcan, followed by her old Zippo. She would have to stop smoking. When the ferry began to dock at Algeciras, she was in the thick of the crowd waiting to disembark. The faces around her were distracted or excited, full of calculation and worry. It wasn't her usual practice to stare into the faces of strangers, but now, because of the blind woman's intimate knowledge of faces, now she could not look away. Each face she saw was a mirror of her own. The eyes of each man and woman who passed struck her like blows. Eyes reveal, she whispered, they're doorways to nakedness. Her own eyes exposed her, allowed passersby to see into her deepest thoughts and opened her to danger. She dug in her purse for the sunglasses she'd found at the airport, cheap plastic shades with palm trees on the temples, and put them on, and felt infinitely better, invincible, like the blind woman. The press of people waiting to exit became intense. From all sides they came, weighed down by backpacks and cameras, clutching giant mineral water bottles and sheaves of travel documents, desperate to be saved. She could smell how fearful they were. And at the last moment, just as the crowd reached the gate, she turned and struggled back to the upper deck. There, she waited until the engines started for the return journey, and the tears came to her eyes. She imagined staying on the ferry as it plied ceaselessly between Europe and Africa. She'd have her baby and it would be a citizen of no country except the stretch of deep water between continents. The baby would be an in-betweener like her. For now, both she and the baby were hungry. At the bar she bought a plate of couscous and the waiter gave her a complimentary cookie. She took the table by the window and treated herself to a glass of wine. Later, she stretched out on a bench on the upper deck and let the rocking of the boat lull her. Sleep came, deep and dreamless. In the morning when the blind woman arrived, Chachiamma would be ready. She'd ask if she might join her at lunch. The blind woman might agree and Chachiamma might become a fixture at her lectures. Why not? There was nothing to stop her, except money. And in her purse was a small wad of dollars, euros, and rupees, and a credit card. The cash would run out soon enough. But before that happened, she'd decide what to do.

WE ARE SAFE HERE

LETICIA BERNAUS

Create, from Latin *creare*:
to produce life or anything else where there was nothing before.

The body accumulates remnants

mezclar

mente

Instinto

breath

something must die

el cuerpo es como la tierra,
una tierra en sí misma

la voluntad está siempre vinculada al cuerpo
los estados del alma son correlativos a los del cuerpo

is the soul born?
or does it enter us at our first breath?
and does it die with us,
is it broken down at death?

what we wish to have belongs in another world

TEXTS FROM THE END OF THE WORLD

SIYANDA MOHUTSIWA

May 2020

Hi

 Hi

What's up?

You still there?

 Yeah

What's wrong?

 Idk...this is hard

It is, but we're supposed to try

 Yeah

I got assigned to you this morning...have you been waiting long?

 No, not really...I didn't think anybody would write to me

Why?

 I don't know...it doesn't matter.

Ok...what are you up to?

 Nothing. Nothing. I'm always up to nothing.

Yeah. That's one thing I hate about this whole pandemic thing. I used to be fun.

 You did?

Haha, are you roasting me?

 What does this mean, to roast...^_^

Means you're making fun of me. Or like teasing me to make yourself laugh.

 Oh! Haha, no. I was asking a serious question...

Oh, ok. Tone is hard to tell over this thing.

Tone?

Nevermind...And to answer your question, I did used to do fun things.

Like what?

I used to go to readings, you know when writers read from their books?

Oh yeah, like poetry.

Yep. I used to go to those at the bookstore and I always went to hear someone read I'd never otherwise pick for myself if that makes sense.

Oh yeah, for sure. Like when you go to a bookshop and choose a book only because you like the color of it's cover?

Yes! Exactly! You get it...

Yup

So anyway, that was one of my favorite things. Before i moved to chicago, I lived in Iowa and there were lots of readings there because of the writers workshop...

The writers workshop?

Oh, its like a master's program for people to get better at writing poems and novels and stories and stuff. Its really famous, I think.

That's cool.

Is there something like that in your country?

Not really. I think maybe long ago poets used to get together on compounds made by the emperor? But i may be making that up.

Oh yeah? I love making things up! So where are you from?

I don't know if we're supposed to share that yet...

This isn't a secret!

Well they assigned me to you for this chat and didn't tell me much about you...

Me too...they told me you're an international student like me and that you study something in the humanities, but that's it...

Same. they said you're international and you study something in the sciences

Cool.

Cool

Listen, I gotta go.

Cool.

...

Talk more tomorrow?

Sure ●

Bye [smile emoji]

Early May

Hey

Good morning

It's morning there?

Yeah, haha

It's still like night time here

Oh cool

Yes too cool

Are you gonna tell me where you are?

No lol

That's not fair, I told you where I am!

I didn't ask you to

●

Its true

Fine

...

...

Are you angry with me?

No, it doesn't matter. None of this matters I guess

Ok I will give you a chance to guess

No its fine

I'm sorry

....

....

It's fine, I have to go though, my brother's calling me

Ok. talk tomorrow?

Mid May

I'm from Taiwan...I'm sorry I didn't say that before. I was just joking around.

I live in Taipei in a building near the NIIT...

Hello?

Are you there?

Late May

Hi!

Oh...hi!

How are you?

I'm fine, and you?

Great...

I thought you were angry with me...

Oh yeah...

Are you?

No! I just...something came up at home and I couldn't really be on my phone as much...

How have you been?

Oh ok

Ok.

Good, like i said

I've been taking walks with my grandma more

Yeah? You guys are allowed to leave?

Haha yes, aren't you?

The government has put in a
curfew. You can't be outside
after 8pm...

Oh wow

yup ...its too hot to be outside
during the day so you end up
being inside all day anyway...

Can people go to work?

Yeah, if you work at night I
think you get a permission
form or something

That's not so bad

Yeah, but there aren't that
many people who work at
night here...not like chicago

And taipei

Oh yeah you guys have the
night market thing right

Yes, i don't go there too often
but tourists really like it

Oh cool!

I used to go there with my
girlfriend more often

Yeah? What did you like to
eat? What did she like to eat...

Oh i don't remember what
she liked to eat

Lol sounds like maybe you
weren't a good boyfriend

....

😵😵😵

Haha...maybe

What happened?

I don't know...she just said she
doesn't want to be together
anymore

Is it because you went to
America for school?

I used to think that, but I know
she has a new boyfriend now
in Japan who she still talks to

How do you know that?

We are in the same group of
friends in a way...

Oh...

What about me haha

Well I don't have a girlfriend
or ex girlfriend...

What??

Woowww

Why are you fighting with
me???

You know what i mean...
you're being weird

....

Well i wasn't

Why? Cause i'm in Africa?

Maybe you thought I got
eaten by a lion or something

Maybe you thought a herd of
wildebeests ran me off a cliff

But as you can see, I'm totally
fine. I didn't become a child
soldier or something

Haha why not!

What about you?

You asked me about my
girlfriend I'm asking you now

😎

It's ok. I'm not like you I won't
get angry if you don't answer
my questions

Is it a lie?

I'm not fighting...

Wait. i'm not the one who just
disappeared for like five days

I was just wondering about
you i thought you were really
angry

But then after some time of
not seeing you online in the
app...i got scared something
happened to you

What????

Hahaha, that's silly.

😂😂😂

Why do you make such
jokes? 😂😂😂

It's too sad maybe.

I find it hard to believe that
Taiwanese people don't make
dark jokes

You're right...

Yup

You made me really laugh
today

I'm glad

This time I have to end the
conversation first. My
grandma is asking for me to
go with her to the store...

Ok.

Bye!

You should get me something

Haha ok I will.

Mid June

You're really cute ^_^

Why do you say this?

Your profile picture! You didn't
have a picture before but now
I can see your new picture

Oh yes!

You are very cute

Thank you! I don't think I am
cute. My grandma says I look
like a baby from the
philippines

What on god's green earth
does that even mean???

I have no idea! My grandma
says so many weird things
about people i can't even tell
you

Then you probably shouldn't
lol

You'll see

I will?

....yeah

Have you gotten your visa
yet?

No...the embassy is closed..

Wait, does Taiwan have a US
Embassy?

Oh...cool! That's a funny work around given your country doesn't exist

I'm kidding!

I'm sorry. Wait is that a bad thing?

I'm sorry I made that joke, obviously your country exists

Ok

K.

Kind of...it's called the American institute

You sound Chinese

....

I have to go

Bye

Early July

You forgot my birthday, T

I'm serious!

No you forgot mine

So am I...my birthday was last week on the 22nd

Wait what??? Mine is the 21st!

We are twins

Whatever

In this economy??

Haha I don't know about that

Did you have a party?

Ha ha. You make that joke too much

Whatever...I didn't have a party

Have you ever had one?

Me too

Not really...my grandma thinks its not important.

Hows she doing lately? Is she feeling better?

Yeah, she had a bit of cold but I took care of her

I can't believe its just you and her

I'm used to it. My father is still in Thailand...he can't leave

I hate this pandemic, so many people are abandoned

As for me, I still don't know if I'll be able to come to US next quarter

Yeah

No way

I know...I've come to accept it...I think maybe I won't go to school at all

Its hard to explain

I don't understand

No its not. Is your father still bothering you?

He's very stressed with his company, he hasn't wanted to fire anybody so money's tight right now

But you have to go to school

I know...he's saying maybe I should just start studying at the university here

That's crazy

Not really. It's a good enough school. University is free here

But its not UChicago

How do you know?

....

???

Did I upset you?

No...

You didn't answer my question...is he still being mean to you?

He's stopped drinking since the government banned alcohol so he's not so crazy

Good

Thanks

Thanks? For what?

For caring...

You're important. And you have to come to America next quarter... you promised to be my friend.

We'll see

Late July

I'm sorry we couldn't talk very long

Its ok! I understand your internet is not that good

Yeah, I don't think the fiber optics thing gets to my village lol

Anyway I like texting more so its fine.. you don't have to see my ugly face

😑 booorrinng

Hehe sorry. You always want me to be confident. "I'm so handsommmmeee"

Haha yeah! That's better

Look at me, I am sooooo beautiful

Hahah

See you're laughing at me

I'm not!

I'm glad you're laughing. I didn't know your eyes close when you smile. It was nice to see that on the video call

Awww...don't make me shy

You make me shy

....lol

.....

....

.....

I have to go...

Ok

😩😩

August

I bet I could cheer you up!

Hi

I bet I could make you smile!

Ok

...you don't sound excited

Well, I'm stressed about my dad

Oh im sorry...I thought...

I haven't heard from him in like 2 days. He was in the hospital but I haven't heard anything in 2 days

Oh my god that's awful

We don't have any family there or anything and it feels scary that anything can happen and I wouldn't know

Jesus christ

So that's why I'm a bit low today

Im sorry honey...I wish I could help you somehow

Yes

Do you like hugs?

Maybe

Well...imagine me giving you the biggest and longest and warmest hug ever and if you cry

I wont cry

Well...im not American or whatever - in my culture men cry all the time. Its ok to cry

Ok

If you cry I will hold you even tighter and try my best to take care of you

....

....

....

Did I say something wrong?

No...not at all.

Ok...I hope I didn't say something wrong

No I just needed to step back for a moment and breathe

Ok...I hope it helped

It did

Great!

So what's the news?

The news?

The good news that would cheer me up 😵 you forget everything

Oooh! I got my visa!!!

Woooooooohhhhh

Yep! I mean I have to wait for it to be mailed from South Africa but I'm basically good to go!

Woooow! You're right – that is some wonderful news

Yess...so I'll be able to keep my promise to you

Promise?

I promised we'd go to uchicago this quarter and that I'd be your friend

Then I can hug you for real

🫥

Perfect

Late August

My dad's home

Yes! Yes! Yes!

Yesssss!!!

I'm so glad.

He's a bit thin but he seems ok.

What happened?

His phone died can you believe it

Hahahah omg

Anyway eventually he got better enough to ask someone to charge it and then he called a friend and begged him to get a flight out

🤷

I thought there were travel bans and stuff

It doesn't matter – I'm so happy for you!

I'm thinking of maybe delaying my enrolment so I can stay here and take care of him

That's sweet of you

Do you think that's a good idea?

I guess it depends on what he thinks...if he thinks that he needs you you'll have to stay

I won't really 'have to'...I want to

Great...

You seem fine with it

???

You don't care whether I come to Chicago or not

What????

I'm serious! I would have begged you to leave your dad in the dust to go to Chicago

Actually...I think you did 😬

I'm not joking around. You think I'm always joking around

No I'm not...wait what's going on??

I just think maybe you don't get it

Get what, T? jesus man
- speak your mind I'm tired of the mind games

Mind games?

You know...when you just disappear and stuff

You're the one who disappears

That's not true

Ok I can't talk to you I'm getting annoyed

Surprise surprise

What's that ?

You're gonna go off and disappear and then you'll be back when you need to talk to someone

Do you really believe that?

....

B

What?

Do you really believe that I'm just using you like that?

....

....

I need to go. I have to go visit some family before I leave for the states.

Fine.

Fine.

Early September

Um when did you send it?

What?

I got a call from the post office and I thought it was for me to get my passport from the embassy

Yeah

I got there and there's this big box from...idk, there was Chinese letters on the box, so I was like...is this a mistake

...

The postmaster assured me it was for me (first of all how did you even get my full name/address???)

You sent me a picture of it

What??

You sent me a picture of your notebook where you were drawing pictures and there was an envelope sticking out at the corner.

Oh my god

Hahaha

Ok, so I get home and open the box and there's just a box of hangers in it

What????

Why would you just send me hangers

Wait

....

Oh you're playing with me

Hahaha you should know by now

I should

There's a teddy bear here with your name embroidered on its tummy and it's a panda bear!!

You have mentioned panda bears like 8 times in one month

Haha

There's a box filled to the brim with Korean beauty maskssss.....!!!!!! There must be like hundreds

No not hundreds, haha – 104 was all I could afford

Wow...

I can't believe it!

See? I do listen to you

It's not a big thing but I am happy you are happy

Did it cost a lot?

Not really, I just snuck onto those big shipping container ships and put the box in a bin that said "To Africa"

why are you like this?

I blame you – you taught me to joke too much

Well I'm glad you sent it. Im so so so happy!

Good...you should be happy

But you haven't answered my question...when did you even send this?

In May....

You asked me to get you something...so I did

I am happy you like it

Wow.

That's so weird...I barely knew you in May! I don't even think I knew you were from Taiwan then 🌐

I know but I knew then that you needed a good surprise from a stranger far far away

Well...I guess you're not a stranger anymore

It depends. Did you find the letter?

Letter?

In the box of face masks

Woooow – nope, let me check and then I'll get back to you.

Take your time...I'm going to bed now – we can talk tomorrow

Ok!

Good night

Thank you so much, T.

No...thank you Bonolo.

Mid September

You land at 2pm right?

I wonder what you smell like

Wha

I mean...on the flight to new york, you know I had a lot of time to think and I started thinking maybe if we meet you won't like my smell

That's crazy

No listen. That letter you wrote (and by the way there's no way you wrote that in May 😜)

Ok fine, I put it in the box in June...after the masks had arrived

Loool I knew it

It changes nothing

TRUE

So now what's the matter?

Well, on the plane, I was thinking that you know we've not really met and like if you saw me in Taipei would you even have talked to me?

Ok...

And I was thinking that what if I come and im so excited to be your uchicago friend and then you smell me and you're like noooooooo

That's actually crazy

Im serious! You know pheromones are like 90% of what attraction is all about...

Fine

And then I started thinking that maybe I am fat and you'll see me and you'll be like ew she's chunky

Ive never said the word "chunky" in my whole life

Listen!

I'm listening

What if you see me and then you smell me and then while you're driving that rental to hyde park or whatever, you kick me right out the door on the highway and then I die and that's it! Then I survived covid for nothing and I went through all that stress and fighting with my dad and begging the government to pay for my flights and going to Johannesburg and crying at the embassy and all that...and then I die ten minutes after I leave ohare....

Wow

See?

You need to eat

What??

You're hungry. When you're hungry, you start to panic.

Oh...I guess I haven't eaten since the plane...

That makes sense, you have nausea on long flights..

Wow...

You like to listen to audiobooks when you go to bed but you have to turn them off right when your eyes go really droopy or you'll end up anxious and awake. You love breakfast foods but when you eat before 10am, you get sleepy. You wish you could run but you also really hate running.

Loooll

These are small things that I know and I haven't even met you yet

Yeah...

So when you get here, all I'll be thinking is how lucky I am to know new things about you. I'll get to know exactly how you smell when you're fresh off a flight and scared that the Taiwanese boy wating for you is gonna think you're fat

Hahaha oh man...its gonna be so crazy when you smell me and learn that you're not into it

Don't do this...not today

....

Don't run from me. You don't need to joke and hide and stuff...you saved my life

What do you mean?

We can talk more later, but I just want to say, things were really hard about my father and I got very despondent thinking about my future if he dies...and my grandma and stuff. But whenever I thought of you...I smiled. Every time. Every single time.

:D

Now im embarrassed

Don't be...I'm embarrassed...

Why?

I'll tell you later, the flight to Chicago is taking off.

Great, I'm in the arrivals.

How will I know you?

I'll be holding a sign that says "You owe me for those facemasks"

Oh my god hahahahah I love you!

Bonolo, I love you too.

Ok. Safe flight and don't forget to eat something!

....oops!

Ok thanks. And don't get covid!

You're annoying

STRUCTURE

SIGNS OF THE TIMES

UZODINMA IWEALA

If you drive south on Fifth Avenue in Manhattan, heading out of Harlem, at 110th street you will encounter a peculiar sight. On the side of a multi-story apartment building, rising almost forty feet tall, in big block letters, the statement BLACK LIVES MATTER floats above the names of Black people killed by the police. The text can't be missed—white letters stenciled on a black background that fills massive trapezoidal windows. It is jarring, a gash in the tranquility; it is perhaps not inaccurate to call it an unpleasant reminder that all is not well in this beautiful part of the city, where bronze statues of Duke Ellington and Tito Puente stand in the tree-lined roundabout and the serene Harlem Meer sits just behind the stately stone wall marking the limit of New York City's iconic Central Park. If you spend a few moments observing the building's entrance, you will notice a steady stream of mostly wealthy, white people, occupants of the luxury apartments in the twenty-two-story tower above. Another entrance is beneath a brown awning adorned with bronze letters in the same font as the BLACK LIVES MATTER mural. It says the Africa Center.

This institution is responsible for this statement in support of Black life. It finds itself engaged in the centuries-old and ongoing struggle to construct a new imaginary, where Black life does matter. This task of the ages is daunting, all the more so in a world that is only just recognizing the delusion of white supremacy that governs nearly every part of its operation; this delusion makes it nearly impossible to imagine or conceptualize a new understanding of the transformative role that art and its supporting institutions can play in shaping a more equitable future.

This assertion, focused as it is on present wrongs, may at first seem pessimistic and limiting, especially in a volume concerned with the idea of possibility. However, I find that the imagination of a radically different future is impossible to render—especially in art and its surrounds—if the (un)reality of the present, which would form its substrate, is not considered. I wonder how we can discuss the possibilities that emerge from collective or individual imagination if that imagination is so circumscribed by a world of untruth? Can art and institutions be truly transformative if born from such poisoned soil? Fascinated as we are by the potential for creation, connectivity, and dreaming that come from both this moment of disruption and the new and often wondrous digital tools we have at our disposal, there is no technology, digital or otherwise, that will undo the creative strictures imposed by the delusion of white supremacy without first assaulting this delusion, fracturing the worldview that is its progeny. And only then, amid the ruins of that psyche, exploring the imaginative landscapes that emerge from such a struggle, can we assault the delusion. Furthermore, it is only in the context of this extremely tenacious delusion of white supremacy that a simple statement of truth—BLACK LIVES MATTER—achieves the status of art, however plainly presented it may be in the world we inhabit.

Delusions are a fascinating and terrifying phenomenon. As a young medical student, I had my first encounter with a delusional patient during my third-year psychiatry rotation, conducted in a locked ward at Columbia University's Milstein Hospital. The man I was assigned to care for, under the supervision of a resident physician not much older than me, and a seasoned neuropsychiatrist, was middle-aged with severe cheekbones and a well-groomed beard very much at odds with the black suit he had clearly worn for days. He arrived in the throes of a manic episode attributable to previously diagnosed bipolar disorder. He was aggressive, and convinced that his family had sent him to the hospital to prevent him from achieving true greatness. He was on the verge of something incredible, he told me, something that would change the world, and his family members were jealous. They wanted to dull his shine. He would make vague pronouncements to me as we sat in a padded room; each day his belief in his own greatness, genius, prowess in business and world affairs grew stronger, alongside the claim that his family, who had brought him out of concern for his own safety, was out to destroy him. No amount of therapeutic conversation with the psychologist and attendant physicians could move him from this position. At the height of his manic state, no factual evidence could convince him that he was not the king

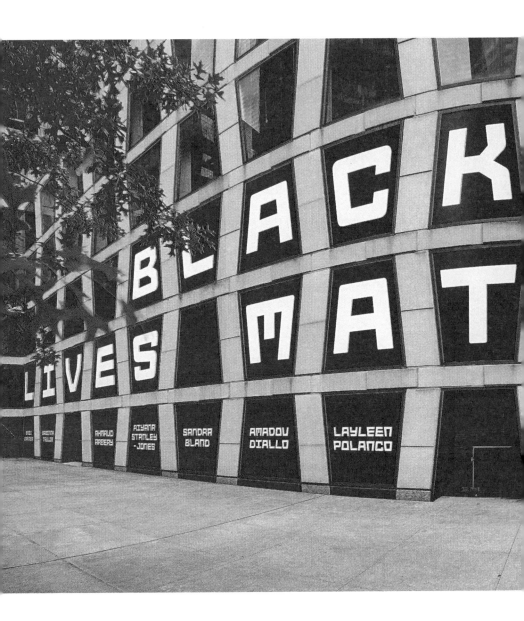

BLACK LIVES MAT
BLACK

SANDRA BLAND AMADOU DIALLO LAYLEEN POLANCO
AHMAUD ARBERY AIYANA STANLEY-JONES

Black Lives Matter window installation at The Africa Center, Harlem, New York City, NY.
Photo by Anita Ng, FRAME Studios, 2020.

of the world in waiting, a supreme business genius on the cusp of billions, but an ordinary person with a severe mental illness, resistant to treatment, in an otherwise unremarkable New York City hospital.

I found his condition fascinating because his conclusions from the events at hand were so far afield from the reality as to be tragically amusing. I found myself terrified because the more time I spent with him, the more I began to question whether his understanding of the world might indeed be real. So convinced and so convincing was he that I began to doubt my own reality. I began to wonder whether we were the ones in the wrong for keeping this possibly brilliant, potentially transformative mind involuntarily confined. I remember the sense of dread that overtook me as soon as this thought popped into my head, the feelings of confusion arising each time I encountered this patient. When I raised the issue with the attending neuropsychiatrist, a seasoned Russian doctor, she said calmly, "So it is with delusions. They believe so completely that sometimes it's hard not to believe it too."

According to the *DSM-5*, the bible of all psychiatric diagnoses, delusions are fixed beliefs that are not amenable to change in light of conflicting evidence. The dictionary is more succinct: a belief that is not true. Mental health professionals would caution strongly against any kind of mass societal diagnosis (not being a psychiatrist I feel unbound by that profession's conventions), but it is difficult not to consider the possibility of delusion in white America—or Euro-American society more generally, to be inclusive—in this deeply held and continuously cultivated belief in white supremacy. So convinced is whiteness of its own superiority that all in its orbit are sucked into and even at times in agreement with a belief system that collapses when it encounters reality. So enamored of the delusion it is that it has been nearly impossible to point out how this belief system, central to which is the devaluation of Black life, does not comport with reality. So convincing is the certainty that white society places on this belief that it can be confusing for a person to hold a contrary belief. More maddening still is the accumulation of power to whiteness that allows for the construction of an (un)reality that condones this delusion. In the words of James Baldwin:

> I do not think, for example, that it is too much to suggest that the American vision of the world—which allows so little reality, generally speaking, for any of the darker forces in human life, which tends until today to paint moral issues in

glaring black and white—owes a great deal to the battle
waged by Americans to maintain between themselves
and black men a human separation which could not
be bridged.[1]

Baldwin's unbridgeable "human separation" that characterizes
an American worldview divorced from reality speaks directly to
this idea of delusion, which would otherwise take volumes to
explicate. Indeed, this has been the thankless task of too many
Black people—scholars, artists, and plain old regular folks—
constantly pressed to affirm our intrinsic worth in the midst of
this delusion. It speaks to both the power of the shared fantasy
of white supremacy and its infuriating grasp that there is even a
question around the scholarship, or worse, around the lived
experience of the Black person documenting the phenomenon.

Without taking too much of a detour, perhaps a dinner
encounter I had in October of 2021 might illustrate the point.
At this event for a conference attended by what I can only
describe as self-proclaimed masters of the universe (read:
mostly white men of a certain age and minimum net worth),
I found myself seated next to an investment manager for a
prominent family foundation. As we sat listening to Van Jones
speak about criminal justice reform, this man—thwarted in
his attempts to chat up the svelte blond woman across from
me—now turned his attention to me. In a brief exchange, he
indicated his alarm about Nigeria's "exploding population and
what a disaster that would be for the world" and I (uninterested
in a full-blown discussion about a deep-seated Euro-American
fear of Black people having babies) softly deflected with the
question, "Who's to say that would be a bad thing?" Next, he
asked me, without malice, as if simply questioning a law of the
universe, "Why do Black people always have to play the
victim?" When I attempted to interrogate the very premise of
his question, our conversation quickly devolved into the absurd.
He suggested that other people in the world have also suffered,
that slavery was not that bad—certainly better than being left in
savage Africa—and that he most certainly should not be
required to pay reparations to me or any other Black person
who was not alive at the time. When I asked why he felt so
strongly about supposed Black victimhood despite so much
evidence to the contrary, when I pointed out that a people who
have been forced to labor for years and treated as second-
class citizens (or worse), and yet who still managed not just to
exist but to thrive and provide essential contributions to the
world could not possibly be described as having a victimhood

mentality, he balked. When I tried to point out how American society, white Euro-American society, was structured to affirm his misapprehensions (e.g., school textbooks whitewashing the horrors of slavery, omitting the massive economic and social contributions of Black people that underpin the structure of the Euro-American world, a whole media complex primed to emphasize narratives of Black criminality, indolence, etc.) he dismissed my words as evidence of a Black victimhood complex. Sensing that further discussion would be simply an exercise in speaking for the sake of speaking, with no impact on his understanding, I drained my Mezcal neat, thanked him for a most enlightening conversation, and excused myself from the event, maintaining the firm belief that it is never profitable to argue with a fool. On my way back to my hotel, I asked myself how a sophisticated and credentialed man could hold such views. And then, accepting the man as a product of his environment, I considered how the institutions that have shaped him and a society that largely agrees with his worldview, actively and passively, play a major role in shaping this distortion.

Since their emergence as public establishments in the early nineteenth century, museums have played a consequential role in how Euro-American society constructs and understands itself. In his seminal work *The Birth of the Museum* (1995), the cultural historian Tony Bennett explores both the origin of the museum as a social institution and its profound impact on the way Euro-American society views itself in relation to the wider world. Positing that the modern museum developed in conjunction with the process of industrialization and the idea of the modern nation state, Bennett emphasizes how practitioners and administrators of the period held faith in the civilizing potential of the museum. Quoting Thomas Greenwood, a Victorian-era publisher and early supporter of the British Museum, who states, "a museum and Free Library are as necessary for the mental and moral health of the citizens as good sanitary arrangements, water supply and street lighting are for their physical health and comfort,"[2] Bennett begins to connect the purpose of the museum to ideas of citizenship and nationality—essentially who belongs, and how they belong to a political entity increasingly concerned with the individual's welfare in relation to their economic productivity. Two necessities became clear to the government at this time: the need to engender in a population a kind of behavior that aided capital in its quest for more capital, and the need to justify the exploitation of certain

populations in the colonies or territories slated for conquest in this quest. The first necessity required the institution to act on behalf of the government to cultivate a sense of "proper" behavior (discouraging drunkenness, lewd behavior, etc.). As such, the idea emerged to consider "high culture as a resource that might be used to regulate the field of social behavior in endowing individuals with new capacities for self-monitoring and self-regulation that the field of culture and modern forms of liberal government most characteristically interrelate."[3] In this sense, the museum became a tool of social control, a form of Jeremy Bentham's principle of all watching all, theorized by Michel Foucault as panopticism—a way to enforce adherence to a shared social construct centered on class and race hierarchies also produced and propagated by the museum. As eighteenth-century Enlightenment philosophies of progress matured alongside a growing need for resources from the periphery of the Empire and beyond, the construction of a wholly fictitious, but immensely powerful, natural and social hierarchy that placed whiteness—in particular, the white man—at the top became an important aspect of this social construct. According to Bennett:

> While important differences remained between competing schools of evolutionary thought throughout the nineteenth century, the predominating tendency was one in which the different times of geology, biology, anthropology, and history were connected to one another so as to form a universal time. Such a temporality links together the stories of the earth's formation, of the development of life on earth, of the evolution of human life out of animal life and its development from "primitive" to "civilized" forms, into a single narrative which posits modern Man (white, male, and middle class), as Catherine Hall (1992) would put it, as the outcome and, in some cases, telos of these processes.[4]

Further ideas of linearity and progress added a scientific veneer to provincial misapprehensions of difference such that Kant's musings on Blackness, written by a man who most certainly had never ventured to Africa (nor most likely ever encountered a Black person), could morph into an institutional design of museums, promoting an understanding of reality in which Black people:

> [...] were typically represented as the still-living examples of the earliest stage in human development, the point of

transition between nature and culture, between ape and man, the missing link necessary to account for the transition between animal and human history. Denied any history of their own, it was the fate of "primitive peoples" to be dropped out of the bottom of human history in order that they might serve, representationally, as it support—underlining the rhetoric of progress by serving as its counterpoints, representing the point at which human history emerges from nature but has not yet properly begun its course.[5]

Here, Bennett observes how ideas about the racial and cultural superiority of whiteness, necessary for the cohesion of resource-hungry, newly forming, and newly industrializing states, were embedded in museum and exhibition designs, which served as enforcers of the imaginary of white superiority, in turn allowing disparately ethnicized and classed Europeans to cooperate in the service of capital.

Once these institutions became a part of propping up the fantasy of white supremacy, by their commitment to displays that enforced racial and social hierarchies, they could repeat this role by excluding or selectively displaying the contributions of this racialized other and over time compounding the impact of this exclusion. In other words, the more often one does not see artwork made by a Black person presented in a museum, or the more one sees it as "less than" art (as in the Primitive Arts section of the Metropolitan Museum of Art), the more likely one is to dismiss Black people as being incapable of producing such work. If the ability to produce such work is one of the defining conditions for full humanity, then it must follow that those excluded are not and have never been fully human, further justifying their exclusion and concomitant devaluation. The unbearable whiteness of these structures makes perfect sense when viewed in light of this process. Why would an institution dedicated from its inception to the idea of Blackness as "less than" have any cause to employ or promote into a position of authority such a subhuman being? It would defy all logic. As such, for the longest time (and presently) these structures never experienced any challenge to their madness, no check to the delusion—and so the delusion grew, as did the madness of the society it underpinned.

I grew up around museums. Washington DC's Smithsonian Institution is free and open to the public, and is a marvelous place for a young person interested in art, history, or science, and the buildings that have been constructed to pay homage

to the wonderful achievements of humans. But as a very young child, I was acutely aware that none of what populated the museums we visited on school trips featured work or stories about anyone who vaguely resembles me. Moreover, the people I encountered working in these places—save the janitors and security—only rarely looked like me. For exhibitions that looked at Blackness or anything related to it, I could go to the Museum of African Art, which was symbolically very much in contrast to the Smithsonian's other institutions: it was located underground, only a small cube of a vestibule on the south side of the mighty Smithsonian castle signifying its presence. The uneasiness of my youth matured into adult anger when confronted with institutions like the British Museum, which held artifacts looted in the era of colonialism, or the Michael Rockefeller Wing for Primitive Arts at the Metropolitan Museum of Art in New York. Cultural departments—even of institutions with some inclination to explore Blackness, Black objects, Black stories, Black art—showed white face after white face, either complicit in or blissfully unaware of the way their institutions denigrated Blackness.

For many people in the United States, March 2020 marked the threshold of incredible change. COVID-19 swept across the globe and, despite travel bans seasoned with xenophobia, the pandemic did not stop at the borders of Fortress America (or Fortress Europe). This was the first time in two decades that the culturally normative fantasy of American invincibility, buoyed by nearly four years of radical Trumpism, met with reality. As the virus moved through urban as well as the preciously idyllic suburban and rural parts of the country with startling efficiency and disregard for the United States' purported superiority, Americans—white Americans to be precise—had to contend with the notion that they are people like other people, just as susceptible to a communicable disease as all other humans on this planet, just as unable to thwart the awesome power of the natural world as their "inferiors" in countries populated by the melanated hordes typically impacted by such events.

In particular, the subjection of white American life to disease, the grinding halt to life as we knew it—as they knew it—brought uncomfortable connections to the country and continent stopping communicable disease epidemics— Ebola, HIV—characteristic, defining if you will, of Blackness in a world structured by white supremacy. Most confusing for Euro-American societies was the fact that the predictions of COVID-induced mass death in Africa never materialized. Instead of people putting their dead into the streets, as the

philanthropist Melinda Gates claimed would happen, the continent, while certainly not unscathed, did not fall apart. As global north newspapers blasted headlines like "Africa has unusually low fatality rates from COVID-19, and scientists are baffled," my mind drifted to that age-old question of whether white people, white society, can truly survive a reality it has not constructed for its benefit. What is whiteness if white bodies and, more importantly, white societies are subject to reality? What is whiteness if the economic system designed to extract value from Black people and the geographic, cultural, and emotional spaces we inhabit can no longer perform its extractive function? Is there even a future?

The various responses to the lockdown, ranging from the liberal-leaning incredulousness at the relatively low death toll in Africa to the conservative politicization of preventive public health measures such as mask wearing and social distancing, seemed an attempt to reconstitute the feeling of safety provided by the delusion of white supremacy. Meanwhile, the platitude "we are all in this together" aimed to maintain the illusion of the United States as a cohesive and supportive environment for all of its citizens, never mind that a large number of the workers most impacted by shutdowns or most exposed to dangerous conditions that fostered COVID were Black.

While global north media spilled much ink and devoted much airtime to the courage of healthcare workers and the solidarity (mostly imagined) of the masses, it seemed to me that these were the questions at stake for a society forced to reckon with whether its grand narrative about itself holds the status of truth. As for the museums—cultural institutions crucial for creating, perpetuating, and propagating this grand narrative? Most found themselves sidelined, unable to welcome visitors, ill-equipped to reach people in their homes, and fumbling to reproduce digital versions of themselves easily accessible at home for the good of a struggling society—though maybe more so for justification of their own existence. The idea of business as usual, even if the platform had changed, appeared to be the move. Rather than focus on what might exist for white society now that the fantasy of supremacy/invincibility had cracked, exposing the unreality these institutions both feed and feed off of, they chose to attempt to patch up its existence, to act as if technology (undoubtedly a product of the white man's genius, attesting to his superiority) could maintain the delusion. And then suddenly, still struggling to shore up its unreal superiority, white America was forced again to confront reality, delivered by the very technologies deployed in the service of maintaining that delusion.

May 25, 2020, the day George Floyd was murdered, will forever be confusing to me. Before George Floyd's murder it was simply Africa Day, a chance to commemorate the 1963 signing of the Charter of the Organization of African Unity (OAU), which later became the African Union. At the time of its signing, most of the 32 signatory countries were newly liberated from the overt manifestations of colonialism, and most certainly "convinced that it is the inalienable right of all people to control their own destiny" and "conscious of the fact that freedom, equality, justice, and dignity are the essential objectives for the achievement of the legitimate aspirations of the African peoples" These words from the preamble to the charter elaborate the idea that BLACK LIVES MATTER, a plainly stated response to firmly reorient the world away from the delusions foisted upon Africanness by extractive colonialism. May 25th, 2020, was also the day that a confrontation between Amy Cooper, a white woman, and Christopher Cooper, an unrelated Black man, Harvard graduate, comic book illustrator, and birding enthusiast, who simply asked Amy Cooper to keep her dog on leash per regulations in a designated birding area of Central Park, went viral.

In the short video, the absurdity of Amy Cooper, pale skinned, brown hair pulled into a sporty ponytail, sweatshirt over a black, cleavage-revealing sports top, yoga pants and running shoes, holding her dog on leash—ever the archetype of a white femininity both battered and sanctified in the delusion of white supremacy—is on full display. The confidence in her aggressive move toward Chris Cooper, who asks her to keep her distance, and the absolute confidence with which she engages the police, certain that her version of reality, the completely fictional account that she was under "attack" by an "African American man," would prevail is sickening.

Also sickening was my watching this clip on repeat, rewinding at the end to the portion where Amy Cooper suddenly switches from outright aggression born of a centuries-old belief that any white person has the right to control the movement of Black bodies in space, to weaponizing the state security apparatus in service of that same belief. The simultaneous beauty and horror of Amy Cooper's action is that it at once exposes the delusion of white supremacy and highlights its intense power. In my more cynical moments, I'm inclined to consider it a masterwork of performance art, an over-the-top dramatization of the obvious sordid state of racial affairs in America. But this thought process, too, is a product of the white supremacists' delusion that seeks to decouple the everyday actions of white people, and the systems they have ordered in

their service, from the visceral consequences these actions have on Black people.

Indeed, one of the more poignant aspects of the immediate commentary on the Amy Cooper video was how many concerned white people focused not on the harm this white woman intended toward a Black man, but on the condition of her obviously distressed dog. One Twitter user commented: "I'm absolutely horrified, that poor dog is absolutely begging her to stop choking him! This woman needs to be arrested and have her dog taken from her. She has no right to be the caretaker of ANY animal." In this reading, the threat to a Black man's life is subordinated to a dog's anxiety. Was there ever a more obvious way to indicate how little black lives matter to white people?

The internet produced a swift reaction to the Amy Cooper video. I remember feeling more than a little elation as she was offered up by the White establishment as a low-stakes sacrifice that would absolve the majority of their own racism, thus preserving the delusion—all the better because the stakes were apparently so low. No one had died. No one was arrested. The only entity that suffered potential physical damage was Amy Cooper's poor dog. Society delivered "justice," a doxing, followed by her employer, the financial services firm Franklin Templeton, issuing a statement without delay distancing itself from her actions: "We take these matters very seriously and we do not condone racism of any kind. While we are in the process of investigating the situation, the employee involved has been put on administrative leave." Again lost to many people was the fact that this company that does not condone racism is proudly named after Benjamin Franklin, who made clear in his 1751 essay "Observations Concerning the Increase of Mankind, Peopling of Countries, etc.":

> The Number of purely white People in the World is proportionally very small. ... And while we are, as I may call it, Scouring our Planet, by clearing America of Woods, and so making this Side of our globe reflect a brighter Light to the Eyes of inhabitants in Mars or Venus, why should we in the sight of Superior Beings darken its people? Why increase Sons of Africa, by Planting them in America where we have so fair an Opportunity, by excluding Blacks and Tawneys, of increasing the lovely white and Red? But perhaps I am partial to the complexion of my Country, for such Kind of Partiality is natural to Mankind.[6]

Benjamin Franklin owned slaves. This is a fact. Benjamin

Franklin considered Blacks to be a lesser kind of people—if people at all—an ineluctable mentality that accompanies the act of owning a person. I would venture that the majority of Franklin Templeton's staff, and certainly the company's PR team, does not know this, and thus would certainly not recognize the absurdity of releasing a statement condemning racism that features the image of a man who (despite or perhaps in service of his abolitionist credentials) actively promoted racist ideas that underpinned racist governance structures. None of this is hidden. Franklin's own words expose his orientation. His own records plainly present his racially selective misanthropy. And yet we are in so deep that even the irony is lost.

During the few hours in which the establishment enacted its ritualistic sacrifice of Amy Cooper, George Floyd was unknowingly living out his last moments. To purchase a pack of cigarettes he unwittingly used a counterfeit twenty-dollar bill, an act that would initiate the events that culminated in his murder.

The video recording of George Floyd's death is difficult to watch for many reasons, chief among them for me the casual disregard that Minneapolis Police Officer Derek Chauvin exhibits as he kneels on the neck of a man begging to breathe. George Floyd says, "You're going to kill me, man," to which Chauvin responds, "Then stop yelling. It takes a heck of a lot of oxygen to talk." Floyd's response—"Can't believe this, man. Mom, love you. Love you. Tell my kids I love them. I'm dead"—is astounding. It is hard to resist the urge to characterize this last exchange as Shakespearean, and immediately make meaning from something that is by systemic design meaningless. Amy Cooper's exile was very much a sacrifice in support of the system. Her punishment has meaning because she is white, and it is momentous to condemn whiteness to social death (especially for exposing the delusion). In contrast, George Floyd's killing required no effort. Officer Chauvin kneels, hands in pockets, exerting no real effort, allowing gravity to do its work as he crushes this "thing" beneath him. But even then, the video exposes the delusion. Conversation between the two men, an act that acknowledges the humanness of the person one engages, that acknowledges the distress, a statement followed by an acknowledgement or response, cannot occur if one does not on some level consider the responder human. Amy Cooper said nothing to the animal as her dog struggled to breathe. Derrick Chauvin, on the other hand, acknowledged Floyd's distress and then actively decided that it didn't matter. It is

jarring, but such an exchange follows exactly the reasoning of some of America's most genius architects, men who considered Black people subhuman and yet somehow still human enough for (forced) sexual intercourse.

As disturbing as this video of George Floyd is, it is not singular. In fact it is impossible to contemplate the power and impact of George Floyd's murder without considering how both this video and the Amy Cooper video are part of a new and instantaneous archive capturing the devaluation of Black life traceable to the filmed 1991 assault of Rodney King by officers from the Los Angeles Police Department. Arguably the first viral video that captures the assault of a Black person at the hands of law enforcement officers, the Rodney King tape, shot on newly available technology—the camcorder—was shared through the old media format of the evening news. As troubling as it was for its aggressive violence, in which four officers take turns beating an already subdued man, as the video of George Floyd's murder is for the almost studied laziness of his assailants, both—and all those in between— are important because they serve to fracture the delusion by capturing for all to see the actual practices necessary to support the structures that allow white Americans to go about their lives carefree and oblivious to the toll their unreality takes on Black people. In the words of former congresswoman Karen Bass: "Many of us who had been trying to convince the public that these kinds of incidents were happening were kind of relieved. Finally it was on camera, and the world was going to be able to see it and we would finally be able to hold police officers accountable."

I'd like to think that the former congresswoman is not as naïve as those words spoken almost thirty years ago seemingly suggest. Her words are more an example of the reality testing that Black people must do on a regular basis in this world of white delusion. All Black people must at some point contend with the fact that the world may not believe many of the things that happen to us as a result of the racist system we inhabit. I know that not one but two police cars blocked the road in front of my house while police officers questioned me, my youngest brother, and his friends for no reason other than we were a group of Black boys in a predominantly wealthy, white neighborhood. Yet the interaction wasn't captured on video so no one would have believed me had anything gone sideways. I know my other brother found himself surrounded by five police officers shouting, with guns drawn, one afternoon. His crime: pulling to the side of the road to call his then-girlfriend so as not to violate the no texting/calling while driving ordinance. There

were no cameras so would anyone have believed him had he not been too scared to do anything except hold onto the steering wheel of our purposefully unthreatening Volvo station wagon?

I was nine years old when I first saw the grainy video of Rodney King assaulted on the Los Angeles streets, surrounded, clubbed, kicked, as one might an inanimate object to let off steam, to express a rage that you otherwise cannot. I remember wondering why these white men were so incredibly angry. I also remember having the jumbled pieces of an answer in my own interactions with the white boys at my Catholic primary school who could go from innocuous to menacing group bullying on the playground in a matter of seconds. Most confusing was never fully understanding what I had done to set them off: winning a foot race, dodging a ball meant for my head, having one of their girls "like" me? I also understood quite early on that there was zero point in appealing to authority figures—white teachers and white mothers who volunteered to watch us at recess—who would invariably affirm that, despite my being picked on relentlessly by a bunch of white boys, I was the aggressor.

If I had to pinpoint the seeds of my anxiety, I might very well choose these years, when my perception of reality was continually overruled by its white construction, and any attempt to question it was perceived as either whining and refusing to accept responsibility for my actions or aggression, rudeness, and incivility. This is not to say that my schooling was entirely torment, but it was just enough that, even at nine years old, I could see the same signs in the replays of repeated bludgeoning of this defenseless Black man: onscreen and in Black minds an already subdued creature; in white reality his very existence at all times an existential threat.

Rodney King's attackers bore no meaningful consequences for the brain damage they inflicted upon him. The video of their attack did nothing to improve society's ability to hold whiteness accountable for its actions, to crack the delusion, primarily because the means of dissemination were that much less democratized thirty years ago than they are now. The miniature analogue tape—analogue still had to pass through the various gatekeepers, who were all white. The cost of a camcorder was still high enough that it was unaffordable to many who might want to document the impact and effects of white delusion, and of course the object was bulky enough that intent was a necessity. You could not be an accidental witness or documentarian. Without social media, you could not, with a few clicks, challenge the dominant worldview.

There have been many videos in between Rodney King and George Floyd that unflinchingly capture the need to reinforce the delusion of white supremacy—both law enforcement officers and everyday white people have been documented policing Blackness. Their creation and dissemination are firmly rooted in our modern moment's ubiquitous cameras and democratized distribution channels. We would not know about Walter Scott if not for the cell phone video that captured a white police officer, Michael Schlager, shooting him in the back eight times at close range, handcuffing his already lifeless body, and then planting evidence at the crime scene. We wouldn't have seen Eric Garner choked to death in broad daylight on a New York City street. We would not have seen Philando Castile, a licensed gun owner, tell a police officer about his legally registered weapon and then get shot anyway, in plain view of his girlfriend and daughter. We wouldn't have known about Ahmaud Arbery, who was gunned down by three white men for doing nothing more offensive than jogging on a Georgia road in the morning. This is an archive of tragedy, an archive of devaluation with a double edge in so warped a society. On the one hand, as politician Bass suggests, for Black people it confirms that our experiences are real.

On the other hand, as Jamil Smith writes in his essay "Videos of Police Killings Are Numbing Us to the Spectacle of Black Death" (2015):

> It seems sickly fitting that those killed by police today are no longer transformed into the anointed or the condemned, but, thanks to more advanced and available technology, they become hashtags. With a flood of more videotaped killings, a hashtag seems a brutally meager epitaph, a mere declaration that a victim of police violence was once alive, human, and didn't merit having her or his life stolen.[7]

Unfortunately, the increased visibility of trauma and death at the hands of cops isn't doing as much as it should be. The legacy of our increased exposure to Black death has merely been the deadening of our collective senses.

The "deadening of our collective senses" speaks to the feeling of inevitability that the delusion of white supremacy seeks to impose on our existences. The repeated viewing of these killings or harassments forms not only the narrative that they happen, but also the narrative that their happening is a

natural part of the societal order, and that nothing can be done to change this. I remember the evening of May 25th—we had barely digested the absurdity of the Amy Cooper video when reports of another video began to circulate on social media, this one without a happy ending, a scene too familiar, added to the catalogue of the delusion in motion.

For a long time I refused to watch the clip of George Floyd's murder because of a personal need to protect myself from images that reinforce how, as the rapper Talib Kweli puts it, "Black life is treated with short worth." Life is precarious, something felt even more so during the first few months of the COVID-19 pandemic. Why subject myself to the constant reminder that not only was my life at risk, but that my death could mean so little and take almost no effort to effect? There was also another point to consider, best articulated by Susan Sontag in her essay "Regarding the Pain of Others" (2003):

> With our dead, there has always been a powerful interdiction against showing the naked face. ... The more remote or exotic the place, the more likely we are to have full frontal views of the dead and dying. ... These sights carry a double message. They show a suffering that is outrageous, unjust, and should be repaired. They confirm that this is the sort of thing which happens in that place.[8]

In this case, that "place" is the Black body wherever it may exist in the world. To show a person's death is to somehow render them less human. As Sontag points out, the decision by American television networks not to display the beheading of the journalist Daniel Pearl to avoid giving air time to the terrorists who captured him and to spare his family from further trauma, emphasizes the sanctity of this man's life. His absence from the screen allows him to transcend death, for his death to hold meaning. Black death gets no such treatment. Whether Philando Castile, Ahmaud Arbery, or Walter Scott, the slaughter and its aftermath are without ritual and their lives rendered as bare life, to borrow from Giorgio Agamben.[9] On the flip side, it is hard not to see how such films can act as official propaganda, much like ISIS videos of infidel beheadings, signaling to others that indeed this destruction of Black life is acceptable. It is no coincidence that there were multiple reported incidents of white people—sometimes in Black face—re-enacting George Floyd's murder, as did high-schoolers in Colorado and Maine, and police officers in York, Pennsylvania.

That white society finds images of Black death entertaining is also no secret. Whether comical, as in Black characters dying within the first five minutes of Hollywood movies, or more aggressively sinister, as in Jim Crow-era pictures and postcards of smiling, picnicking white families at lynchings where Black bodies, fresh in death, dangled from trees, whiteness has always managed to appropriate Black death for its benefit and entertainment. Herein lies the Achilles heel of the digital video archive of Black suffering. Images may fail to properly convey the context surrounding events, or they may be deliberately misinterpreted. In her essay "On Photography" (1997), Sontag drives this point forward when she writes:

> A photograph changes according to the context in which it is seen ... photographs will seem different on a contact sheet, in a gallery, in a political demonstration, in a police file, in a photographic magazine, in a general news magazine, in a book, on a living-room wall. Each of these situations suggests a different use for the photographs but none can secure their meaning. As Wittgenstein argued for words, that the meaning *is* the use—so for each photograph. And it is in this way that the presence and proliferation of all photographs contributes to the erosion of the very notion of meaning, to that parceling out of the truth into relative truths which is taken for granted by the modern liberal consciousness.[10]

When considering video, Sontag's argument still stands. The meaning of this archive of Black death, Black suffering, Black abuse, Black pain is at once concrete and also so abstracted in this ever-growing collection that it becomes whatever the viewer wants it to be. The total democratization of the means of both production and distribution via the internet allows anyone to do as they please with the images. In many ways, this ensures that the ultimate context is that of the dominant group. Whether that means entertainment or obliviousness, the results are still the same: the perpetuation of delusion and the subtle (or not so subtle) celebration of white power.

I remember when I first encountered Black Lives Matter— not when it first began as a hashtag launched after George Zimmerman was acquitted for murdering the unarmed teenager Trayvon Martin, but later, after Police Officer Darren Wilson killed 18-year-old Michael Brown on the streets of Ferguson, Missouri, in August of 2014. I had arrived in Washington DC from Lagos, Nigeria, for the US Africa business summit, a splashy

affair put on by the Obama administration to convey American interest in an otherwise neglected continent. That weekend, after long days of speeches and late-night parties affirming Black Africa's ascendency, Michael Brown was killed. Almost immediately protests and demonstrations erupted on Ferguson's streets while the reporters narrated the scene in their anodyne voices. Cable news showed clips of this young man's body, uncovered and left to rot on the baking asphalt like roadkill, denied in death a dignity also hard to come by in his short life. The internet erupted again with the hashtag #BlackLivesMatter, as did street protests. At the time, I expressed annoyance with the slogan. It felt too simple, too obvious, but also futile. On the one hand, I ranted to a friend, of course Black Lives Matter— my life matters and I shouldn't need to shout it to the heavens or carry a placard to affirm this. On the other hand, Michael Brown's dead body, Trayvon Martin's dead body, the countless number of Black dead bodies that form the foundation of the industrialized West, suggested otherwise.

There is power in this duality just as there is real power in the fact that the words Black Lives Matter need not be accompanied by any images. Whether spoken softly at a dinner table, shouted with raised, clenched fist at a march, or written on a poster, graffitied on an enslaver's statue, or plastered on storefront windows, these words open up space for contemplation in an image-oriented society. The brilliance of the boldly declarative statement is that it asserts a historical truth: Black life has inherent worth and Black lives have always been consequential in the ordering of our world. It also harnesses the power of political precarity by forcing the speaker or placard bearer to ask, "But do they really?" And if not, then what is my role in constructing this situation? The words also bring to the fore the age-old question, *"What is Black life?"*—which is really a challenge to the absurd understandings of skin color, gender, sexual orientation, and class that shape our world.

There is real power as well in considering Black Lives Matter as a phenomenon that could bridge the digital reach of technology with the importance of physical presence in protest. This is true of the proliferation of signs and posters, both commercial and homemade, in windows, on storefronts, spray painted as murals on the street, just as it is of the physical presence of Black bodies and non-Black people who marched in solidarity. Eminently reproducible and customizable, the words work like a virus by stealthily invading the hyper-individualized mentality of a relentlessly atomizing digital-age population. They achieve a coveted hybrid of physical and digital vitality that few instances of digital activism have managed.

When New York City's protests erupted—as did many other cities' across America, indeed the world—in the days following George Floyd's killing, the power of the Black Lives Matter statement and sign showed itself in full effect. Streets once empty because of COVID restrictions teemed with people shouting the words, holding the words, parading the words, through skyscraper canyons, all directed by #BLACKLIVESMATTER as a digital calling card able to direct events in real life. Very quickly the hashtag found its way into nearly every commercial establishment, a small window sign, a line on a menu, even printed on server's shirts. If protest is a form of hyper-political performance art, then BLACK LIVES MATTER may be the most successful participatory performance ever imagined, with whole cities as sets transformed by decentralized design and all inhabitants, whether willing or unwilling, as audience and participants.

This is, in a sense, how one begins to fracture the delusion. One could not *not* see the signs. Even if the very sight of them irritated your core being—and then you would have to ask yourself, on some level, why. Even responses designed to pull attention away from the multiple messages and meanings of #BLACKLIVESMATTER (most notably #ALLLIVESMATTER and #BLUELIVESMATTER) had to first acknowledge the discomfort generated by this glitch in an otherwise unperturbed system of white supremacy before working to paper over the fissure. How perfect and powerful the piece of artwork created by all for all, experienced by all—for some as an awakening to the power of the politically vulnerable and for others an awakening, however rude, to the existence of white supremacy as a chosen belief system (now with evidence of the frustratingly intense mental work necessary for its preservation) rather than a natural state.

All of the hysterical paroxysms the United States is currently experiencing around Critical Race Theory, the banning of books that mention race or slavery in our school systems, and the crusades against "wokeness" point to shock at the rupture of the delusion. I make no guarantees that the powers that be will not successfully find a way to repair this glitch, but I am comforted by the idea that with each passing day, white people become more aware of the enormous cost of its reconstitution—freedom, their precious freedom, and perhaps even the democracy they hold most sacred.

If museums and cultural institutions were created to help order the world then I can see no higher task than participating in the process of delusion busting. That is what I envision when I see our sign rising against the side of the Africa Center. I see that the world has changed, and it will never be the same. #BLACKLIVESMATTER.

Notes

1. James Baldwin, "Stranger in the Village," in *Notes of a Native Son* (Boston: Beacon Press, 1955), https://www.janvaneyck.nl/site/assets/files/2312/baldwin.pdf.

2. Tony Bennett, *The Birth of the Museum: History, Theory, Politics* (London: Routledge, 1995), 18.

3. Tony Bennett, *The Birth of the Museum*, 20.

4. Tony Bennett, *The Birth of the Museum*, 39.

5. Tony Bennett, *The Birth of the Museum*, 78–79.

6. Benjamin Franklin, "Observations Concerning the Increase of Mankind" (1751), Founders Online, https://founders.archives.gov/documents/Franklin/01-04-02-0080.

7. Jamil Smith, "Videos of Police Killings Are Numbing Us to the Spectacle of Black Death," *The New Republic*, April 13, 2015, https://newrepublic.com/article/121527/what-does-seeing-black-men-die-do-you.

8. Susan Sontag, *Regarding the Pain of Others* (New York: Picador, 2003), 55.

9. Giorgio Agamben, *Homo Sacer: Sovereign Power and Bare Life*, trans. Daniel Heller-Roazen (Stanford: Stanford University Press, 1998).

10. Susan Sontag, *On Photography* (New York: Penguin, 2002), 82.

H FOR HUMIDITY – KEYWORDS AND NOTES ON INFRASTRUCTURES, WATER AND WATER-ENGINEERING IN SINGAPORE

HO TZU NYEN

Absolute Nothingness / If infrastructures are the technical grounds upon which other technical systems operate, to think infrastructurally is to move from the made to the making, a mutually transformational or recursive process, that cannot be causally predetermined, nor purposefully produced. According to Kitaro Nishida, "to say that a thing acts must be to say that it negates itself, so that what we call a thing necessarily disappears. […] While everything that really exists is a being by virtue of its having been determined, which is to say that it has been made, it is therefore changing and ephemeral, so we can say that it is being-qua-nothingness. Thus, I have said that this is a world of absolute nothingness and that, as a world of infinite movement, it is a determined world without determinants."[1]

1. Kitaro Nishida, "Absolute-Contradictory Self-Identity" (1939), trans. Christopher Southward, Comparative Literature Faculty Scholarship 10 (December 2018): https://orb.binghamton.edu/comparative_literature_fac/10. I have used "concrete real world" in place of Southward's "the actually existing world" following Junichi Murata, "Creativity of Technology: An Origin of Modernity," in *Modernity and Technology*, ed. Thomas J. Misa, Philip Brey, and Andrew Feenberg (Cambridge, MA: The MIT Press, 2003), 233.

Aesthetics / "Aesthetics are […] part of the ambient life that infrastructures give rise to—the tactile ways in which we hear, smell, feel as we move through the world."[2]

2. Brian Larkin, "Promising Forms: The Political Aesthetics of Infrastructure," in *The Promise of Infrastructure*, ed. Nikhil Anand, Akhil Gupta, and Hannah Appel (Durham, NC: Duke University Press, 2018), 177.

Air Conditioning / In a 2009 interview, Lee Kuan Yew, who served as Singapore's prime minister from 1959 to 1990, remarked: "Air conditioning was a most important invention for us, perhaps one of the signal inventions of history. It changed the nature of civilization by making development possible in the tropics."[3]

3. Lee Kuan Yew, "The East Asian Way—With Air Conditioning," *New Perspectives Quarterly* 26, no. 4 (September 2009): 111-20.

Aggregate / Infrastructures are large, layered, and complex aggregated compounds and to speak of an infrastructure always requires an act of delineation. As Bruno Latour puts it, "for *any aggregate*, a process of redefinition is needed, one that requires curved talk to trace, or temporarily to retrace, its outline. There is no group without (re) grouping, no regrouping without

mobilizing talk. [...] For each aggregate to be shaped and reshaped, a particular, appropriate dose of politics is needed."[4]

4. Bruno Latour, "What if We *Talked* Politics a Little?" *Contemporary Political Theory* 2, no. 2 (July 2003): 149.

Ambience / Infrastructures produce the ambient conditions of everyday life. They regulate our sensorial ecology and affect our experience of qualities such as softness and hardness (e.g., a muddy path versus a concrete path), our sense of temperature (e.g., air conditioning, ventilation), and our perception of noise and fluorescence. Infrastructure can also generate a "feeling" of modernity, a sense of progress, or of the lack of progress.[5]

5. Larkin, "The Politics and Poetics of Infrastructure," 327–43.

Ambiguity / The multiple—and often unexpected—uses (or abuses) of infrastructure result in its characteristic ambiguity.[6]

6. Susan Leigh Star and Karen Ruhleder, "Steps Toward an Ecology of Infrastructure: Design and Access for Large Information Spaces," in *Boundary Objects and Beyond: Working with Leigh Star*, ed. Geoffrey C. Bowker, Stefan Timmermans, Adele E. Clarke, and Ellen Balka (Cambridge, MA: The MIT Press, 2016).

Assemblage / Infrastructures are "complex assemblages that bring all manner of human, nonhuman, and natural agents into a multitude of continuous liaisons across geographic space."[7]

7. Stephen Graham, "When Infrastructures Fail," in *Disrupted Cities: When Infrastructure Fails*, ed. Stephen Graham (London and New York: Routledge, 2010), 11.

Black Box / Black boxing is "the way scientific and technical work is made invisible by its own success. When a machine runs efficiently, when a matter of fact is settled, one need focus only on its inputs and outputs and not on its internal complexity. Thus, paradoxically, the more science and technology

succeed, the more opaque and obscure they become."[8] Infrastructures that function smoothly over a long duration become black boxes to their users.[9]

8. Bruno Latour, *Pandora's Hope: Essays on the Reality of Science Studies* (Cambridge, MA: Harvard University Press, 1999), 304.

9. Michel Callon and Bruno Latour, "Unscrewing the Big Leviathan: How Actors Macro-Structure Reality and how Sociologists Help Them to Do So," in *Advances in Social Theory and Methodology: Toward an Integration of Micro- and Macro-Sociologies*, ed. K. Knorr-Cetina and A. V. Cicourel (London and New York: Routledge, 1981), 285–89.

Boundary Objects / Infrastructures are without absolute boundaries on *a priori* definition. They are "boundary objects"—"objects which are both plastic enough to adapt to local needs and the constraints of several parties employing them, yet robust enough to maintain a common identity across sites."[10]

10. Susan Leigh Star and James R. Griesemer, "Institutional Ecology, 'Translations' and Boundary Objects: Amateurs and Professionals in Berkeley's Museum of Vertebrate Zoology 1907-39," in *Boundary Objects and Beyond*.

Breakdown / Nothing directs our attention to how infrastructures work like a moment of breakdown. One way to delineate an infrastructural system is through its breakdowns and gaps.

Calculative Reason / The infrastructural concept indicates "a form of calculative reason that, from specialized origins, has come to organize social expectations, everyday experiences, and public discourses about the proper relationships among economy, development, governance, and technology."[11]

11. Ashley Carse, "Keyword: Infrastructure: How a Humble French Engineering Term Shaped the Modern World," in *Infrastructures and Social Complexity: A Companion*, ed. Penny Harvey, Casper Bruun Jensen, and Atsuro Morita (London and New York: Routledge, 2017), 28.

Canalization (I) / In hydrography, canalization refers to the process of introducing weirs and locks to a river in order to secure a defined depth suitable for navigation.

Canalization (II) / In psychology, canalization refers to the channeling of an organism's needs into fixed behavior patterns.

Canalization (III) / In developmental psychology, canalization describes "attachment styles"—the inborn systems and mechanisms that allow a child to develop an attachment to a caregiver even if children are exposed to differing environments and situations.

Canalization (IV) / In evolutionary genetics, canalization is the phenomenon of the same phenotypes being produced by a genotype even though the environment may differ, thereby referring to the repression and containment of variation within narrow bounds.

Canalization (V) / In neurology, canalization refers to the greater ease of impulse transmission through repeated use of a specific neural pathway.

Cascade / Disruptions to one infrastructure (e.g., natural disasters or war) have the propensity to cascade through different infrastructural networks across space and time in highly unpredictable and nonlinear ways.[12] Disruptions of life-sustaining infrastructures in the aftermath of an earthquake or a bombing often prove to be deadlier that the events themselves.

12. Richard G. Little, "Managing the Risk of Cascading Failure in Complex Urban Infrastructures," in *Disrupted Cities*, 29.

Chokepoints (I) / The precolonial thalassocracies of Southeast Asia such as the Srivijaya (seventh to twelfth century CE) and the Majapahit (thirteenth to early sixteenth century CE) were hydraulic empires, where the exercise of power was closely tied to the control of water access and techniques regulating its flow. The modus operandi of these maritime empires was the control of coastlines and strategic "chokepoints" along river-ways. One central chokepoint of the Srivijaya was the Strait of Malacca, which is today vital to global trade. About a quarter of all goods and all oil transported by sea (more than fifteen million barrels per day) passes through the Strait of Malacca, making it second only to the Strait of Hormuz in oil transport by volume.[13] At its narrowest point, the strait is a mere one and a half miles wide, making ships susceptible to blockades and piracy, which is prevalent in the area.

13. See Drake Long, "Thinking Like a Pirate: Contesting Southeast Asia's Chokepoints," Center for International Maritime Security, https://cimsec.org/thinking-like-a-pirate-contesting-southeast-asias-chokepoints/, and John Mauldin, "2 Choke Points that Threaten Oil Trade between the Persian Gulf and East Asia," *Forbes*, April 17, 2017, https://www.forbes.com/sites/johnmauldin/2017/04/17/2-choke-points-that-threaten-oil-trade-between-persian-gulf-and-east-asia/?sh=31bbead04b96.

Chokepoints (II) / In social ecology, chokepoints refer to the properties of social-ecological systems that "constrain progress toward an environmental objective. Chokepoints are a complex mix of social, political, or psychological obstructions, congestions, or blockages that decrease the power of society to reach its objectives."[14]

14. Tavis Potts, et al., "Detecting Critical Choke Points for Achieving Good Environmental Status in European Seas," *Ecology and Society* 20, no. 1 (March 2015): 29.

Circulation / In a 1982 interview, Michel Foucault said, "It is true that for me, architecture, in the very vague analyses of it that I have been able to conduct, is only taken as an element of support, to ensure a certain allocation of people in space, a canalization of their circulation, as well as the coding of their reciprocal relations. So it is not only considered as an element in space, but is especially thought of as a plunge into a field of social relations in which it brings about some specific effects."[15]

15. Michel Foucault, "Space, Knowledge," in Power, vol. 3, *Essential Works of Foucault 1954–1984*, ed. James D. Faubion (London: Penguin, 2001), 361–62.

Clock / "The clock is not merely a means of keeping track of the hours, but of synchronizing the actions of men. […] The clock, not the steam-engine, is the key-machine of the modern industrial age. … In its relationship to determinable quantities of energy, to standardization, to automatic action, and finally to its own special product, accurate timing, the clock has been the foremost machine in modern technologies; and at each period it has remained in the lead: it marks a perfection toward which other machines aspire."[16]

16. Lewis Mumford, *Technics and Civilization* (London: Routledge & Kegan Paul, 1967), 14.

Concrete (I) / The mixture of cement, aggregate, and water known as concrete is an infinitely pliable *politic plastic* that can "divide, connect, elevate, detrude, exclude, contain, disperse, and channel the circulation of people and things long after it initially sets."[17]

17. See Penelope Harvey, "Cementing Relations: The Materiality of Roads and Public Spaces in Provincial Peru," *Social Analysis: The International Journal of Anthropology* 54, no. 2, Images of Power and the Power of Images (Summer 2010). See also Mark Usher, "Government of Water, Circulation and the City: Transforming Singapore from Tropical 'Backwater' to Global 'Hydrohub'" (PhD diss., University of Manchester, 2014), 88.

Concrete (II) / As a building material, concrete seems to connote a feeling of modernity.

Concrete (III) / "The emphasis on making things concrete," Richard Sennett tells us, "is a reflection of the value modern culture puts on objects— objects endowed with solidity and integrity. Conventionally, the concrete seems solid, terra firma."[18]

18. Richard Sennett, *The Conscience of the Eye: The Design and Social Life of Cities* (New York: W. W. Norton, 1990), 209.

Conventions / "Infrastructure both shapes and is shaped by the conventions of a community of practice, for example, the ways that cycles of day-night work are affected by and affect electrical power rates and needs."[19]

19. Star and Ruhleder, "Steps Toward an Ecology of Infrastructure."

Disposition / An infrastructural system can be grasped by its disposition, which is "the character or propensity of an organization that results from all its activity. It is the medium, not the message […]. It is not the text but the constantly updating software that manages the text. Not the object form, but the active form."[20]

20. Keller Easterling, *Extrastatecraft: The Power of Infrastructure Space* (London: Verso, 2016).

Deculverting / Waterway deculverting refers to the notion (in urban infrastructural planning) of no longer concealing water channels, but rather exposing them as lifestyle features. Also known as "naturalizing" or "daylighting," deculverting "has been celebrated for providing the technical means through which environmental and socio-economic objectives can be

achieved simultaneously, allowing for the improvement of water quality, stream hydrology and biodiversity, whilst opening up more land to recreational use and thereby increasing property values and rents by as much as 20 percent."[21]

21. Usher, "Government of Water, Circulation and the City," 44.

Depth / The word "infrastructure" suggests a relationship of depth and surface, and as such, a hierarchy. Its origins are tied to a form of calculative reason, which was (and remains) useful for institutions seeking to demarcate responsibility and investment.

Downstream / Communities living downstream of a river often find themselves at the mercy of their upstream neighbors. These can range from bad waste management flowing downstream to the formation of chokepoints—deliberate constrictions as part of a riverine biopolitics. In business parlance, "downstream" is used to describe the latter stages of a product's journey, just before it reaches its targeted consumers, who are the furthest downstream.[22]

22. By Kenneth Tay.

Drains / "ROWDIES PUSH LEE INTO A DRAIN"—title of an article in Singapore's main English daily newspaper, *The Straits Times*, September 9, 1963. The article reports, "The Prime Minister, Mr Lee Kuan Yew, was attacked and pushed into a monsoon drain tonight in a melee involving leaders of the Singapore Business House Employees' Union and Mr Lee's supporters outside the union's headquarters in Towner Road."[23] An example of the unexpected use (and abuse) of infrastructure.

23. By Johann Yamin. "Rowdies Push Lee into a Drain," *The Straits Times*, September 9, 1963, https://eresources.nlb.gov.sg/newspapers/Digitised/Article/straitstimes19630909-1.2.4.

Earth (I) / To think of infrastructures is to think of the grounds on which other objects operate. Yet "infrastructures such as pipes, roads, and cables should not be considered a solid and static base because they rest on, or are built into, a further base—the earth, with its rocks, soil, and water."[24]

24. Andrew Barry, "Infrastructure and the Earth," in *Infrastructures and Social Complexity*, 187.

Earth (II) / The earth in which infrastructures are embedded is itself neither static nor stable.[25]

25. Barry, "Infrastructure and the Earth," 187.

Ecological Thinking / "Ecological thinking is attentive to the capacity of relation-creation, to how different beings affect each other, to what they do to each other, the internal 'poiesis' of a particular configuration. It requires a form of relational thinking, which is different from that of a 'network' which is constructed around alliances and connections (usually strategic). Speaking of ecology inevitably invokes life and death. Ecological thinking involves the acknowledgment of finitude (and renewal) and therefore a certain resistance to the deliriums of infinitude of extension metaphors. That is also why ecological thinking cannot avoid ethical and political thinking of consequences of world-destruction and, as a corollary, of the possibilities of regeneration."[26]

26. Maria Puig de la Bellacasa, "Ecological Thinking, Material Spirituality, and the Poetics of Infrastructure," in *Boundary Objects and Beyond*.

Embeddedness / Infrastructure is, by definition, always embedded, "sunk" into, or "nested" within other structures,

social arrangements, and technologies.[27]

27. Star and Ruhleder, "Steps Toward an Ecology of Infrastructure."

Emergence / Careful attention to the emergence of potentially novel political forms out of infrastructural arrangements is important, as such reconfigurations are often barely perceptible, being akin to what François Jullien has called "silent transformations", *Silent*, he writes: "since 'everything' within it transforms itself, it is never sufficiently differentiated to be perceptible."[28]

28. Cited from Casper Bruun Jensen and Atsuro Morita, "Infrastructures as Ontological Experiments," *Engaging Science, Technology, and Society* 1 (2015): 85. See also François Jullien, *The Silent Transformations*, trans. Michael Richardson and Krzysztof Fijałkowski (London: Seagull Books, 2011), 8.

Enabler / Whatever else an infrastructure might be it must always serve as the foundation that enables something else to happen. What do infrastructures do? They enable. And what allows them to enable? The storage and expenditure of energy. Infrastructures can thus also be viewed as "potential energy."[29]

29. Dominic Boyer, "Infrastructure, Potential Energy, Revolution," in *The Promise of Infrastructure*, 226–27.

Extrastatecraft / "As a site of multiple, overlapping, or nested forms of sovereignty, where domestic and transnational jurisdictions collide, infrastructure space becomes a medium of what might be called extrastatecraft —a portmanteau describing the often undisclosed activities outside of, in addition to, and sometimes even in partnership with statecraft."[30]

30. Easterling, *Extrastatecraft*.

Figures / Infrastructure is usually treated as that which is "under" another structure, a (back) ground, or a taken-for-granted substrate that allows our world to operate. There are moments when infrastructures can be inverted to become

figures: moments of breakdowns; publicity (e.g., state announcements of infrastructural budgets and "innovations"); critical intervention (e.g., writing about infrastructure); sabotage (e.g., blowing up dams).

Fluids / "Fluids travel easily. They 'flow,' 'spill,' 'run out,' 'splash,' 'pour over,' 'leak,' 'flood,' 'spray,' 'drip,' 'seep,' 'ooze'; unlike solids, they are not easily stopped. [...] These are reasons to consider 'fluidity' or 'liquidity' as fitting metaphors when we wish to grasp the nature of the present, in many ways novel, phase in the history of modernity."[31]

31. Zygmunt Bauman, *Liquid Modernity* (Cambridge: Polity Press, 2000), 2.

Flood Control / In the early years of Singapore's postcolonial independence, flooding was regarded as something that can and should be completely contained through technological and infrastructural interventions. This has changed in recent years as the relevant national agencies, with more accurate hydrological modeling, regard the total prevention of flooding as impossible, especially in conditions of climate change. Flooding is now an inevitable condition that must be lived with, and any intervention must first be subjected to socioeconomic cost-benefit analyses.[32]

32. Usher, "Government of Water, Circulation and the City," 112.

Force / Infrastructures are aggregates that involve multiple scales of forces— from the human body to the geophysical.[33]

33. Paul N. Edwards, "Infrastructure and Modernity: Force, Time, and Social Organization in the History of Sociotechnical Systems," in *Modernity and Technology*, 192.

Form / Infrastructures as form address the people who use them, stimulating emotions of hope and pessimism, nostalgia and desire, frustration and

anger that constitute promise (and its failure) as an emotive and political force. At its broadest level, form is also a matter of ordering. It is about the structuring and patterning of experience, imposing order on the world. Form forms things. It operates upon people and makes them into particular sorts of subjects.[34]

34. Larkin, "Promising Forms: The Political Aesthetics of Infrastructure," in *The Promise of Infrastructure*, 175-77.

Fragility / In conversation with Bruno Latour, Michel Serres contemplates an old vase before noting that while it takes skill, patience, and effort to make it, all that is required to destroy it is a push.[35] Likewise, infrastructures are marked by fragility, haunted by a specter of their future breakdown.

35. Cited in Penny Harvey, Casper Bruun Jensen, and Atsuro Morita, "Introduction: Infrastructural Complications," in *Infrastructures and Social Complexity*, 11.

Friction / Infrastructures like roads and railways can overcome the friction caused by difficult terrain, to enable speedy transitions through landscapes such as forests and hills. But infrastructures themselves, once built, constitute a form of friction in time. They become resistant to rapid change, often becoming a source of friction or an impasse to social transformation.

Future Perfect / Urban infrastructure projects are almost always imagined and implemented with future world-making goals. Therefore, infrastructural time is not merely chronological: it gathers past and future into meaningful narratives and turns the present into a state of anticipation. "The tense of infrastructure ... is therefore the future perfect, an anticipatory state around which different subjects gather their promises and aspirations."[36]

36. Kregg Hetherington, "Surveying the Future Perfect: Anthropology, Development and the Promise of Infrastructure," in *Infrastructures and Social Complexity*, 40.

Ground (I) / Infrastructures are "objects that create the grounds on which other objects operate."[37]

37. Larkin, "The Politics and Poetics of Infrastructure," 329.

Ground (II) / Grounding is a concept explored in metaphysics. Consider an ordinary physical object, such as a table, and the atoms of which it is made. Without the atoms, the table would not exist. The table's existence depends on the existence of the atoms. This kind of dependence is called "grounding" to distinguish it from other kinds of dependence (such as cause and effect). It is sometimes called metaphysical or ontological dependence. Grounding can be characterized as a relation between a ground and a grounded entity. The ground exists on a more fundamental level than the grounded entity, in the sense that the grounded entity depends for its existence or its properties on its ground.

Ground (III) / "To call reality itself absolute nothingness [as did Kitaro Nishida], then, is to say that all of reality is subject to the dialectic of being and not-being, that the identity of each thing is bound to an absolute contradictoriness. In other words, nothingness not only relativizes the 'ground of being,' it relativizes any model of co-existence or harmony that sublates, transcends, debilitates, or otherwise obscures that contrariness. At the same time, it is to say that the ascent of nothingness to self-awareness in human consciousness, 'to see being itself directly as nothingness,' is both the place at which the self can directly intuit itself and the place at which the absolute becomes most fully real."[38]

38. James W. Heisig, *Philosophers of Nothingness: An Essay on the Kyoto School* (Honolulu: University of Hawai'i Press, 2001), 63

Gutta-percha / Gutta-percha is a gum resin obtained from trees of the *Sapotaceae* family, found in the Malay Peninsula and used extensively by the British to insulate undersea telegraph cables as it could be molded like rubber, but would not crumble underwater.[39]

39. By Johann Yamin.

History / "According to Fernand Braudel, endeavouring to produce a total history 'is like trying to chart a river with no banks, no source and no mouth'. To navigate these whirling torrents of time, Braudel distinguished between three different levels of historical analysis. For long-term patterns such as environmental change, Braudel identified the ocean as an appropriate metaphor with its vast, undulating expanses. Tides would come next, representing the cyclical patterns of social and economic development measured in decades. The next level down would be analogised to waves, signifying the choppy tumult of current events which can be sensed in an everyday register."[40]

40. Usher, "Government of Water, Circulation and the City," 27. See Fernand Braudel, *The Perspective of the World, vol. 3, Civilization and Capitalism, 15th–18th Century*, trans. Siân Reynold (New York: Harper & Row, 1984), 17.

Humidity / Humidity is ambient oppression, at once imperceptible and visceral. A human subject in a humid atmosphere is prone to breathing difficulties and respiratory conditions such as asthma, along with symptoms of hyperventilation, chronic anxiety, numbness, faintness, dizziness, fatigue, nausea, and loss of concentration. Water vapors in the air palpably impede the body's normal processes of heat dissipation primarily by preventing sweat from evaporating. And if the environment is as warm as, or warmer than the skin, the heat-carrying blood that has risen to the body surface is also prevented from cooling via conduction into the air. This results in a continuous surging of blood to the body surface and a corollary reduction of blood flow to the active muscles, the brain, and other internal organs, which in turn brings about a decline of physical strength, and a loss of alertness and mental capacity, a condition known as "heat stress," which in extreme cases leads to death by heat stroke.

Hydraulics / By the beginning of the Common Era, two distinct but sometimes overlapping forms of polities had emerged in Southeast Asia. The first, typically associated with continental Southeast Asia, were religious-political systems centered on wet-rice agriculture. These were societies organized around the construction of large-scale irrigation and drainage systems. The second—more commonly found in archipelagic or island Southeast Asia—were thalassocracies that struggled for the control of coastlines and strategic chokepoints along riverways. Both forms of polities were hydraulic in nature, wherein the exercise of power is closely aligned with techniques of distributing bodies through the manipulation of water flows and pressure.

Hydrography / Water is a constant and central feature in descriptions of early Southeast Asia. Closed in on the north by the mountain ranges of the eastern Himalayas and internally choked by dense tropical forests and swamps, this region was difficult to access by land, but everywhere it opened up to navigable

waterways. Histories of the region are hydrographical, connected to the physical features of water bodies.

Hydrology / Water not only flows, but also freezes and evaporates. To think of, and with, water is to engage in multiphasic thought, attendant to qualitative phase changes, cyclical transformations, and atmospheric, ambient modulations.

Inertia / Infrastructure does not grow anew; it wrestles with the inertia of the installed base and inherits strengths and limitations from that base. For example, optical fibers are usually laid alongside old railroad lines and new systems are often designed for backward compatibility.[41]

41. Star and Ruhleder, "Steps Toward an Ecology of Infrastructure."

Information / "Infrastructure space has become a medium of information. The information resides in invisible, powerful activities that determine how objects and content are organized and circulated. Infrastructure space, with the power and currency of software, is an operating system for shaping the city."[42]

42. Easterling, *Extrastatecraft*.

Infrastructure / "The *Oxford English Dictionary* tells us that the word infrastructure came to English from French in 1927, citing an early reference in *Chambers's Journal* to a French railroad project: 'The tunnels, bridges, culverts, and "infrastructure" work generally of the Aix to Bourg-Madame line have been completed.' ... infrastructure was initially an organizational and accounting term used to distinguish the construction work that was literally conducted beneath unlaid tracks (roadbeds) or was otherwise organizationally prior to them (surveys, plans, bridges, tunnels, embankments) from the superstructure of roads, train stations, and workshops that was situated above or constructed after the tracks. In the post-war era, infrastructure was both an ascendant term and an increasingly abstract concept. Moving beyond engineering, it took on new meanings through the intertwined projects of supranational military coordination and international economic development."[43]

43. Carse, "Keyword: infrastructure," in *Infrastructures and Social Complexity*, 28-29.

Inversion / Geoffrey Bowker's concept of "infrastructural inversion" is designed to bring the infrastructural "ground" up front, treating it as "figure" in order to draw attention to the silent, unnoticed work done by infrastructures, such that (to adopt Erving Goffman's terms) the built environment's "backstage" becomes momentarily "frontstaged."[44]

44. Graham, "When Infrastructures Fail," 18.

Invisibility (I) / "Good, usable [infrastructure] systems disappear almost by definition. The easier they are to use the harder they are to see. As well, most of the time, the bigger they are, the harder they are to see."[45]

45. Geoffrey C. Bowker and Susan Leigh Star, *Sorting Things Out: Classification and Its Consequences* (Cambridge, MA: The MIT Press, 2000), 33.

Invisibility (II) / In places where infrastructure seems always in need of repair, or where it is unfinished, infrastructural invisibility is an elusive goal.[46]

46. Hetherington, "Surveying the Future Perfect," 42.

Invisibility (III) / The notion of infrastructure as invisible is disproved by the many instances of infrastructure attaining hyper-visibility as an object of desire or as a spectacular sign of "progress."

Irrigation / Through the construction of large-scale irrigation and drainage systems, "padi-politics" was born. This refers to both planting rice and rendering the population sedentary, countable, and taxable.[47]

47. James C. Scott, *The Art of Not Being Governed: An Anarchist History of Upland Southeast Asia* (New Haven, CT: Yale University Press, 2009).

Leakage / Leakage seems inevitable in every kind of infrastructure.

Littoral / Littoral zones, as liminal spaces between land and sea, offer a critical site to think through fluid territories. Hydrographical maps only capture a freeze frame of littoral zones, and not the full range of their transformations.[48]

48. By Kenneth Tay.

Logistics / The postwar ascent of infrastructural reason was accompanied by the rise of the science of logistics. The etymology of "logistics" can be traced to the Greek *logistikos*, which means skilled in calculating. The word was primarily used in military science, where it once played a subservient role to strategy and tactics. But things began to change with the rise of modern technological and petroleum-based warfare, where the success or failure of campaigns came to rely on a logistical system critical for the feeding of men and machines alike. Thus over the course of the twentieth century a reversal of sorts took place and logistics began to lead rather than

serve strategy. But by the 1960s, the science of logistics, armed with quantitative techniques that would be increasingly amplified by the calculating power of computers, came to redefine business science. By the latter half of the twentieth century, logistics and its paradigmatic space of the supply chain had become a vital system, critical not only to trade, but to the sustenance of life itself. This is apparent in the increasing militarization and securitization of supply chains in the networked infrastructure of postwar global capitalism.

Lubricant / Stored in great reservoirs and channeled via pipes to all corners of the territory, water is a critical lubricant for industrialization, urbanization, and agricultural intensification.[49]

49. Karen Bakker, "Water: Political, Biopolitical, Material," *Social Studies of Science* 42, no. 4 (August 2012): 618.

Maintenance / The impurities and imperfections within an infrastructural system are not aberrations to be scrubbed from the system, but are rather the very gist of what constitutes our relationships to infrastructure.[50] The constant maintenance required for infrastructure results in a sense of interminability—a task that is never to be done once and for all, but rather requires constant revisitations.

50. Jonathan Rutherford, *Redeploying Urban Infrastructure: The Politics of Urban Socio-Technical Futures* (Cham, Switzerland: Palgrave Macmillan, 2020), 29.

Measure / "Most nineteenth-century European observers mixed non-technological or non-scientific gauges—systems of governance, ethical codes, gender policies, religious practices, and the like—with assessments of African and Asian material mastery. By the twentieth

century, however, colonial administrators and missionaries, travelers, and social commentators increasingly stressed technological and scientific standards as the most reliable basis for comparisons between societies and civilizations. In an age when 'scientific' proofs were increasingly demanded of those engaged in the study of natural history and social development, material achievement and anatomical measurements proved irresistible gauges of human capabilities and worth. Mechanical principles and mathematical propositions could be tested; bridges, machines, and head sizes could be measured and rated for efficiency. Thus, unlike earlier gauges by which the Europeans compared societies, those favored in the nineteenth century were believed to be amenable to empirical verification and were especially suited to the late Victorian penchant for 'statistical reductiveness'."[51]

51. Michael Adas, *Machines as the Measures of Men: Science, Technology, and Ideologies of Western Dominance* (Ithaca, NY: Cornell University Press, 1991), 144–45.

Mediation / Because infrastructures "are things and also the relations between things," they are always involved in mediation. They both conduct and serve as conduits (e.g., for the transit of energy, bodies, and resources).[52]

52. Larkin, "The Politics and Poetics of Infrastructure," 329.

Membership / Infrastructure requires a "taken-for-grantedness" of artifacts and organizational arrangements. As such it is characterized by a (sometimes compulsory) membership in a community of practice. "Strangers and outsiders encounter

infrastructure as a target object to be learned about and new participants acquire a naturalized familiarity with its objects as they become members."[53]

53. Star and Ruhleder, "Steps Toward an Ecology of Infrastructure."

Membrane / Selective filtration processes enabled by membranes are critical for the development of desalination and water-recycling processes.

Metrics / "The translation of society into countable quantities has made it possible to use arithmetic [and] geometric and graphic arts to order reality and represent social relationships in terms of mathematical ratios or graphic images, thereby compressing a huge amount of information. Expressing everything in numbers creates the impression that the universe is written in mathematical terms and subject to the same logic. This means of representing social phenomena has given rise to a geometry and an algebra of the social—a form of representational statistics."[54]

54. Eva Barlösius, "Die Macht der Repräsentation," in *Gesellschaftsbilder im Umbruch: Soziologische Perspektiven in Deutschland*, ed. Eva Barlösius, Hans-Peter Müller, and Steffen Sigmund (Wiesbaden, Germany: VS Verlag für Sozialwissenschaften, 2001), 179–202. Cited from Steffen Mau, *The Metric Society: On the Quantification of the Social*, trans. Sharon Howe (Cambridge: Polity Press, 2019).

Modernity / Initiatives involving engineered infrastructural systems are tightly bound to modernist notions of progress and development.[55]

55. Adapted from Harvey, Jensen, and Morita, "Introduction: Infrastructural Complications," 7.

Mosquito / Some of the earliest water-engineering efforts in Singapore were focused on the draining of marshes, in part to prevent the outbreak of malaria carried by the *Anopheles* mosquito. However, the subsequent canalization of Singapore created a network of concrete drains and culverts that was favorable for the

breeding of the *Aedes* mosquito—a vector for dengue in urban environments. In 2020, the COVID-19 pandemic brought about a series of lockdown measures, which multiplied the possibilities for human and *Aedes* mosquito encounters, resulting in a historic high for dengue transmissions on the island state.[56]

56. Usher, "Government of Water, Circulation and the City," 140. See also Salma Khalik, "More People Have Died from Dengue than from COVID-19 in Singapore This Year," *The Straits Times*, November 19, 2020, https://www.straitstimes.com/singapore/health/more-people-have-died-from-dengue-than-from-covid-19-in-singapore-this-year.

Multiplicity / Infrastructures operate on differing levels simultaneously, generating multiple forms of address.[57]

57. Adapted from Larkin, "The Politics and Poetics of Infrastructure," 330.

Nature (I) / To think infrastructurally is to analyze the *nature of government* (how the conduct of citizens is calculated, manipulated, and aligned with utilitarian, propitious ends) and the *government of nature* (management of the biophysical surroundings of the population and the circulation of environmental resources).[58]

58. Adapted from Usher, "Government of Water, Circulation and the City," 34.

Nature (II) / "Infrastructures constitute an artificial environment, channelling and/or reproducing those properties of the natural environment that we find most useful and comfortable; providing others that the natural environment cannot; and eliminating features we find dangerous, uncomfortable, or merely inconvenient. In doing so, they simultaneously constitute our experience of the natural environment, as commodity, object of romantic or pastoralist emotions and aesthetic sensibilities, or occasional impediment. They also structure nature as resource,

fuel, or 'raw material,' which must be shaped and processed by technological means to satisfy human ends."[59]

59. Edwards, "Infrastructure and Modernity," 189.

Network / Before it was employed as a general spatial concept to describe urban spaces and communication lines, the term "network" was used in the hydrological sciences.[60] The earliest occurrence of "network" in print is the Geneva bible of 1560, where it refers to a type of brickwork that generates a net-like pattern. A recorded 1658 usage refers to reticulate structures in animals and plants. From 1839, it was used in reference to rivers and canals; from 1869, to describe railway systems; and from 1883, to describe electrical cables. By 1914 it was employed in reference to "a wireless broadcasting network," and, by 1934, as a term in psychology that designates an "interconnected group of people." By 1972, it was used in reference to computers; a decade later, it acquired another meaning, "to interact with others to exchange information and develop contacts."[61]

60. Adapted from contribution by Kenneth Tay.

61. See Keith Briggs, "Etymology of the Words Network, Net, and Work," Keith Briggs, 2004, http://keithbriggs.info/network.html; "Network," *Online Etymology Dictionary*, https://www.etymonline.com/word/network.

NEWater / Desalination and water-recycling processes gradually became economical during the 1990s as the cost of membrane technology required for the critical process of reverse osmosis decreased by approximately fifty percent. Recycled "NEWater," as branded by the Singaporean state water authority Public Utilities Board (PUB), was launched in 2000 primarily for non-potable use, although it would be progressively added to the island state's reservoirs in greater amounts.[62]

62. Usher, "Government of Water, Circulation and the City," 26.

Nusantara / "Nusantara": the islands in between (from Sanskrit, *nusa* = island, *antara* = in between, used in Old Javanese texts to refer to the outer islands beyond the Majapahit Empire).[63]

63. By Johann Yamin.

Oriental Despotism / *Oriental Despotism: A Comparative Study of Total Power* (1957) is a book of political theory and comparative history by Karl August Wittfogel, where the despotism of "Oriental" societies was analyzed in relation to the centralized control of water, for irrigation and flood control. Managing these projects required large-scale bureaucracies, which dominated the economy, society, and religious life in what he termed the Orient. The book was subsequently criticized for its monolithic view of the "Orient."

Oscillating View / The only possible view of infrastructures is one that oscillates—between invisibility/hyper-visibility, original intentions of design/unpredictability of use, all-encompassing solution/omnipresent problem.[64]

64. Casper Bruun Jensen and Atsuro Morita, "Infrastructures as Ontological Experiments," *Engaging Science, Technology, and Society* 1 (2015): 82.

People / Social relations are central, hidden, and vital supports to the running of infrastructural systems necessary for living in cities. People are infrastructure.[65]

65. Hannah Appel, Nikhil Anand, and Akhil Gupta, "Temporality, Politics, and the Promise of Infrastructure," in *The Promise of Infrastructure*, 12.

Persistence / Infrastructures persist. Once installed, they are hard to reverse.

Infrastructures fix not only space, but time—they lay out the future.[66]

66. Akhil Gupta, "The Future in Ruins: Thoughts on the Temporality of Infrastructure," in *The Promise of Infrastructure*, 63.

Politics (I) / "Infrastructure, like science, is politics pursued by other means."[67]

67. Appel, Anand, and Gupta, "Temporality, Politics, and the Promise of Infrastructure," 10.

Politics (II) / "War is the continuation of politics by other means."[68]

68. Carl von Clausewitz, *On War*, trans. Michael Howard and Peter Paret (1976; repr., Princeton, NJ: Princeton University Press, 1984), 87. Clausewitz's formula—arguably the best-known (and perhaps most contested) definition of war—reads in the original German as "Der Krieg ist eine bloße Fortsetzung der Politik mit anderen Mitteln." In the 1976 "standard" English translation, Michael Howard and Peter Paret rendered it as "War is merely the continuation of policy by other means." In English, both "policy" and "politics" are reasonable options for the translation of the German word *Politik*, and both have been used interchangeably by Clausewitz's various English translators and commentators. "Political intercourse," "political activity," "political affairs," and even "polity" (which emphasizes the influence of organized groups and social structures in war) have also been used by various scholars and interpreters.

Porosity / Starting in late 1997, the Ministry of Sustainability and the Environment in Singapore began lining drains with a porous geotextile lining called "Enkadrain ST," which would "allow water to percolate through to a sub-soil layer where steep gradient reconstruction was not possible, thereby keeping drains relatively dry [...]. Drainage engineer Lim Meng Check acknowledged that lining drains with Enkadrain ST would cost 10 percent more than conventional methods but they would filter water, prevent mosquito breeding and only require cleaning once every week rather than alternate days, thereby alleviating the manpower shortage."[69]

69. Usher, "Government of Water, Circulation and the City," 142.

Potential Energy / In the first chapter of *Capital* Marx wrote: "As values, all commodities are only definite masses of congealed labor time."[70] Dominic Boyer asks if it is possible to invert the inertia of

infrastructure and its resistance to change into a potential energy storage system, to see infrastructure not as material forms and more as an "energopolitical" process that allows change to take place. [71]

70. Karl Marx, *Capital: A Critique of Political Economy*, vol. 1, trans. Ben Fowkes (London: Penguin Books, 1976), 141. Also cited in Boyer, "Infrastructure, Potential Energy, Revolution," 227.

71. Boyer, "Infrastructure, Potential Energy, Revolution," 226–28.

Probabilities / Michel Foucault distinguishes between two modes of political power. The first is "disciplinary mechanism," which functions by "laying down a law and fixing a punishment for the person who breaks it, which is the system of the legal code with a binary division between the permitted and the prohibited."[72] Its exemplary spaces are those of enclosure, such as schools, hospitals, barracks, asylums, and prisons. The second is the "apparatus [*dispositif*] of security," which operates through the management of circulations in an open space, without the binary division of the permitted and the prohibited. Its exemplary spaces are that of the neoliberal state where each phenomenon (such as flooding or an epidemic) is subjected to statistical renderings of probability and inserted into a system of cost calculation."[73]

72. Michel Foucault, *Security, Territory, Population: Lectures at the Collège De France 1977-1978*, ed. Michel Senallart, trans. Graham Burchell (Basingstoke, UK: Palgrave Macmillan, 2007), 6.

73. Foucault, *Security, Territory, Population*, 6.

Processes / "Infrastructures are flaky accretions of sociomaterial processes that are brought into being through relations with human bodies, discourses, and other things (sewage, soil, water, filtration plants). They are processes always in formation and [...] always coming apart."[74]

74. Nikhil Anand, *Hydraulic City: Water and the Infrastructures of Citizenship in Mumbai* (Durham, NC: Duke University Press, 2017), 12.

Protocol / Every infrastructural system is accompanied by an integrated system of protocols in which the user is enmeshed—a techno-political apparatus through which governance could be orchestrated from a distance.[75]

75. Usher, "Government of Water, Circulation and the City," 87.

Quaculation / An activity that Nigel Thrift defines as "arising out of the construction of new generative microworlds which allow many millions of calculations continually to be made in the background of any encounter." Accord to Thrift, "it is no longer possible to think of calculation as necessarily being precise. Rather, because of massive increases in computing power, it has become a means of making qualitative judgements and working with ambiguity. In other words, what we are seeing is a new form of seeing, one which tracks and can cope with uncertainty in ways previously unknown."[76]

76. Nigel Thrift, "Movement-Space: The Changing Domain of Thinking Resulting from the Development of New Kinds of Spatial Awareness," *Economy and Society* 33, no. 4 (2004): 584.

Quart / One imperial quart = 1 chupak, a Malay unit of volume equivalent to half a coconut shell. Used to measure everything from water to rice, it is part of a broader system of volumetric measurement used at regional ports up until the early twentieth century: 4 chupak = 8 leng (pint) = 16 chentong (cup) = 1 gantang (gallon). Used proverbially to describe a people's way of life and customs: "melihat cupak gantang orang"—to see other people's weights and measures (*Hikayat Siak*).[77]

77. By Faris Joraimi.

Reason / "In the Western imagination, reason has long belonged to *terra firma*.

Island or continent, it repels water with a solid stubbornness: it only concedes its sand. As for unreason, it has been aquatic from the depths of time and that until fairly recently. And more precisely oceanic: infinite space, uncertain Madness is the flowing liquid exterior of rocky reason."[78]

78. Michel Foucault, "L'eau et la folie" (1963), in *Dits et écrits, Tome I: 1954-1975* (Paris: Gallimard, 2001), 268. This passage is translated by Clare O'Farrell, cited in Usher, "Government of Water, Circulation and the City," 14.

Reverse Osmosis / Reverse osmosis (RO) is a water-purification process that works by forcing water through a partially permeable membrane in order to separate ions, unwanted molecules, and larger particles like bacteria from drinking water. Reverse osmosis works by using an applied pressure—either hydrostatic or hydraulic, to overcome osmotic pressure. It is a key technology for desalination and the production of NEWater in Singapore.

Recursivity / There is a recursive relation between the making of infrastructure and the shaping of society. While engineers and builders made railways, the experience of transportation on trains produced new perceptions of speed, distance, and time, which, in turn, could become the impetus or imprint for new forms of infrastructural development. Oil infrastructures emerged concurrently with particular political formations, types of warfare, lifestyles, and forms of what Timothy Mitchell calls "carbon democracy," which in turn made oil seem indispensable. In all of these instances, we are witness to a recursive movement wherein forms of infrastructure generate effects that loop back upon society, organizations, and people, re-shaping them. [79]

79. Harvey, Jensen, and Morita, "Introduction: Infrastructural Complications," 11.

Relationality / Infrastructures are "things and also the relation between things."[80]

80. Larkin, "The Politics and Poetics of Infrastructure," 329.

Responsibility / "Infrastructures are shaped by multiple agents with competing interests and capacities, engaged in an indefinite set of distributed interactions over extended periods of time. The characteristics of infrastructure emerge out of these interactions, making it exceedingly unlikely that they will function according to the plans of anyone in particular. This notion of infrastructural emergence is important because it indexes the experimental character of infrastructure development. However emergence introduces a troubling political issue, since responsibility for infrastructural effects can no longer be straightforwardly attributed to the autonomous choices of individuals or even organizations."[81]

81. Harvey, Jensen, and Morita, "Introduction: Infrastructural Complications," 10.

Reservoir / The word "reservoir" refers not to any body of water, but specifically a body of water that is treated as a "standing reserve," existing only as potential for future usage. [82]

82. By Kenneth Tay.

Revenge Effect / "In the developed world, probably the large majority of 'natural disaster'-related injuries and deaths are actually caused not directly by the natural event itself, but indirectly by its effects on infrastructures. [...] Edward Tenner calls these 'revenge effects' of technology. The effects of such failures can be magnified

by interdependencies among infrastructures. For example, natural cataclysms can cripple one infrastructure, such as the emergency services system, by taking out others, such as the telephone system and the roadway network. Indeed, we depend so heavily on these infrastructures that the category of 'natural disaster' really refers primarily to this relationship between natural events and infrastructures."[83]

83. Adapted from Edwards, "Infrastructure and Modernity," 193.

Revolutionary Infrastructure /

"Infrastructure stores the productive powers of labor — mental, material, natural — in such a way that they can be released later in magnitudes that appear to transcend nominal inputs."[84] To convert a conservative notion of infrastructure into one that is revolutionary, Dominic Boyer suggests an imagining of how the potential energy congealed in infrastructures can be released to "blow the very same arrangement 'sky-high.'"[85]

84. Boyer, "Infrastructure, Potential Energy, Revolution," 229.

85. Boyer, "Infrastructure, Potential Energy, Revolution," 231.

Security / According to Foucault, earlier modes of governance rely on disciplinary mechanisms that demarcate absolute boundaries, while the current apparatuses of security operate within the calculation of an acceptable range. In place of establishing limits and frontiers, apparatuses of security pivoted on a guarantee of circulation. "Discipline is centripetal but security is centrifugal and subsumptive; it promotes the continual expansion of existing systems, opens up processes to extraneous activities or things, thereby '[n]ew elements are constantly being integrated ...

allowing the development of ever-wider circuits.'"[86]

86. Usher, "Government of Water, Circulation and the City," 50.

Scaling / "[I]f to be modern is to live within multiple, linked infrastructures, then it is also to inhabit and traverse multiple scales of force, time, and social organization."[87]

87. Edwards, "Infrastructure and Modernity," 186.

Sociotechnical / "'Infrastructure' is often used as if it were synonymous with 'hardware.' But all infrastructures (indeed, all 'technologies') are in fact sociotechnical in nature."[88]

88. Edwards, "Infrastructure and Modernity," 188.

Solution / "Infrastructure today seems both an all-encompassing solution and an omnipresent problem, indispensable yet unsatisfactory, always already there yet always an unfinished work in progress."[89]

89. Rutherford, Redeploying Urban Infrastructure, 10.

Standards / The implementation of standards is required for infrastructures to function. Standardization allows for one infrastructural system to be plugged into another.[90]

90. Star and Ruhleder, "Steps Toward an Ecology of Infrastructure."

Statistic / Governmentalities today pivot on risk calculations that are closely linked to the emergence of a (relatively) new science: statistics. Statistics, which etymologically means the science of the state, utilizes advances in probability studies to produce an accounting of the forces and resources that constitute a state at a given moment. "For example: knowledge of the population, the measure of its quantity, mortality,

natality: reckoning of the different categories of individuals in a state and of their wealth; assessment of the potential wealth available to the state, mines and forests, etcetera; assessment of the wealth in circulation, of the balance of trade, and measure of the effects of taxes and duties, all this data, and more besides, now constitute the essential content of the sovereign's knowledge."[91]

91. Foucault, *Security, Territory, Population*, 274.

Substrate / One common way to think of infrastructure is as a system of substrates that underlies the built phenomenal world, such as pipes, cables, sewers, and wires. This view presumes a clear, linear relationship between an underlying system and the phenomenal world to which it gives rise, when this relationship is in actuality often far more difficult to define.[92]

92. Larkin, "The Politics and Poetics of Infrastructure," 329.

Surveillance / "First, by homogenising the dimensions of waterways through geometric canalisation the flow of water could be regularised, thereby enabling efficient, calculable conveyance and hydrological measurements. [...] Beginning in 1968, hydrometric stations, flood gauges, telemetric systems and CCTV technology would be progressively embedded within the [Singaporean] canal system to facilitate surveillance and policing of both stormwater and proximate passers-by."[93]

93. Usher, "Government of Water, Circulation and the City," 212.

System / An infrastructure is usually an amalgam of technical, administrative, and financial techniques. To place the system at the center of analysis decenters technology and offers a more synthetic perspective, adding to our conception of machines all sorts of non-technological

elements.[94]

94. Larkin, "The Politics and Poetics of Infrastructure," 330.

Transparency / Infrastructure is transparent to use, in the sense that it does not have to be reinvented each time or assembled for each task, but invisibly supports those tasks.[95]

95. Susan Leigh Star, "The Ethnography of Infrastructure," in *Boundary Objects and Beyond.*

Trapezoid / The archetypal form of concrete drains is that of a trapezoidal cross section. Discharge through a channel of trapezoidal section is maximum when the sloping side is equal to half the width at the top.

Temporalities / Infrastructures accrete different temporalities. As such they manifest a strange and uneasy coexistence of multiple times. Infrastructures consist of a present that exists, a past that persists, and a future that insists.

Temporal Trap / The promise of infrastructure is an aspirational mode for some subjects. The future perfect is "the condition within which most self-styled pioneers live: not in hope of remaining as they are, but in hope that their current hardship will have been the necessary precursor to future prosperity." This same form of infrastructural thinking can turn into "a temporal trap for certain subjects (such as indigenous people) who are condemned to disappearance in an emerging order."[96]

96. Hetherington, "Surveying the Future Perfect," 42.

Time (I) / The predecessor of the mechanized clock was the *clepsydra* ("water-thief" in Greek), or the water clock, "a vessel that takes in or gives out water in an even flow—one could avoid machinery altogether by reading the time directly

from a scale marking the height of the water; or, if one wanted to drive wheels, one could use a float and toothed rod to communicate the thrust of rising water to a train. This latter method went back to antiquity and was practised in both Europe and Asia.[97] According to David Landes, Chinese water clocks, powered by water movement for the mapping of celestial bodies, were probably the most advanced timekeepers of their time (circa eleventh century).

97. See David Landes, *Revolution in Time: Clocks and the Making of the Modern World* (Cambridge, MA: The Belknap Press of Harvard University Press, 1983), 8.

Time (II) / The mechanical clock time, which developed in the Middle Ages in Europe, was driven by the energy of a falling weight through a gear train (wheels and pinions). Cut off from the elements (the motion of water) and freed from the task of mapping the stars, it was (unlike the water clock) impervious to frost and (unlike the sundial) it works through the night and on cloudless days. [98]

98. Landes, *Revolution in Time*, 6-7.

Time (III) / "The [mechanized] clock," Lewis Mumford tells us, "not the steam engine, is the key machine of the modern industrial age."[99] Mechanized time is the infrastructure that enables the functioning and synchronization of other large technical systems.

99. Mumford, *Technics and Civilization*, 14.

Time (IV) / The official deployment of GMT in 1884 is said to have heralded a new era of global timekeeping in allowing "people, towns, cities, ports, railways, and colonies to connect with metropolitan centers, and between each other, through a single space-time matrix."[100]

100. Vanessa Ogle, *The Global Transformation of Time 1870-1950* (Cambridge, MA: Harvard University Press, 2015), 76.

Time (V) / "In the vast swaths of territory beyond Europe and North America, across oceans, deserts and steppes, and impenetrable jungles, sweeping narratives of successful time unification, discipline, and coordination quickly go amiss."[101]

101. Ogle, *The Global Transformation of Time*, 76.

Time (VI) / "The specific character of human time is one reason infrastructures fade into invisibility between moments of breakdown. Human time scales are set by our natural (animal) characteristics: the horizon of death; the salience of extremes; the fading and distortion of memory; the slow, faltering process of learning; and our restless, present-centered, single-focus attention, among many others."[102]

102. Edwards, "Infrastructure and Modernity," 194-95.

Time (VII) / Outside rare moments of creation or major transitions, infrastructures change too slowly for most of us to notice; the stately pace of infrastructural change is part of their reassuring stability. They exist, as it were, chiefly in historical time. Partly because of this, infrastructures possess the power to shape human time, shaping the preconditions under which we experience time's structure and its passage."[103]

103. Edwards, "Infrastructure and Modernity," 194-95.

Time Control / "Infrastructure has its conceptual roots in the Enlightenment idea of a world in movement and open to change where the free circulation of goods, ideas, and people created the possibility of progress. This mode of thought is why the provision of infrastructures is so intimately caught up with the sense of shaping modern

society and realizing the future. They are 'mechanisms to control time,' [...] instigating 'waves of societal progress,' and possession of electricity, railways, and running water came to define civilization itself. In this sense, it is very difficult to disentangle infrastructures from evolutionary ways of thinking [...]."[104]

104. Larkin, "The Politics and Poetics of Infrastructure," 332.

Undercurrents / Water currents moving contrary to those on the surface, like covert influences that underlie prevailing atmospheres.[105]

105. By Johann Yamin.

Urbanization / The notion of urbanization begins not from land but from the seas. The concept can first be traced back to Spanish engineer Ildefons Cerdà (1815–1876), who wanted to fill the earth with the boundless vitality of the oceans, as a means to break the political enclosures on land. This was, in other words, an urbanization that attempted to wash the land of petty local politics in favor of a universal, boundless economy. [106]

106. By Kenneth Tay.

Visibility / It is almost a commonplace to say that infrastructures are usually regarded as invisible until moments of breakdown. Brian Larkin argues that, on the contrary, infrastructures can inhabit a whole spectrum of visibilities, from opacity to spectacle, the latter in which infrastructures, far from being invisible, were designed to elicit awe and admiration.[107]

107. Harvey, Jensen, and Morita, "Introduction: Infrastructural Complications," 10.

War / The imbrication of economy, energy, vital resources, governance, technology, and security within infrastructural networks is the reason that civilian and military targets can no longer

be distinguished. "Contemporary intersections of political violence and infrastructure," Stephen Graham tells us, "further blur traditional binaries separating 'war' and 'peace,' the 'local' and the 'global,' the 'civil' and 'military' spheres, and the 'inside' and 'outside' of nation-states. Such trends suggest that potentially boundless and continuous landscapes of conflict, risk, and unpredictable attack are currently emerging, as the everyday infrastructures sustaining urban life on an urbanizing planet, usually taken for granted and ignored, become key mechanisms for the projection of state (and nonstate) violence."[108]

108. Stephen Graham, "Disruption by Design" in *Disrupted Cities*, 121.

Water (I) / Flowing through the hydrological cycle, water links individual bodies to one another through the cycling of waters and water-borne effluents between water bodies and organisms—both human and nonhuman. As it flows, water transgresses geopolitical boundaries, defies jurisdictions, pits upstream against downstream users, and creates competition between economic sectors, both for its use and for its disposal (invoking intertwined issues of water quantity and quality). Water is thus intensely political in a conventional sense, implicated in contested relationships of power and authority.[109]

109. Bakker, "Water: Political, Biopolitical, Material," 616.

Water (II) / Water plays a central yet ambivalent role in different myths related to the emergence of life or the founding of a people in Southeast Asia (for example, through the union of a local woman with a man who has arrived from the sea). It is attributed with the powers of healing and purification, just as it is commonly dreaded

as the source of epidemics, bad spirits, and "bad deaths" (e.g., drowning, death by crocodile).[110] Water does not, in itself, possess a value that is unequivocally positive or negative; rather, it enables the transition between good and evil. As a lubricant for transgressing boundaries of all kinds, it facilitates passage across inanimate and animate states (the emergence of life) and dissolves the separation between the inside and the outside (the birth of a people through the synthesis of the local and foreign).[111]

110. For example, the cosmology of the Ngaju Dayak of Borneo is centered on the notion of a life-giving water stored up within the Tree of Life, while many tribes in Indonesia attribute their origins to the union of a local woman with an "overseas" man. See Peter Boomgaard, "A State of Flux" in World of Water: Rain, Rivers and Seas in Southeast Asian Histories (Leiden: KITLV Press, 2007), 5-7.

111. A variant of the common Indonesian myth of origin through the local woman and "overseas" man is also present in the account of the founding of the Funan kingdom, which emerged on the lower Mekong Delta between the first and sixth century CE. It was said that a woman ruler of that region led an attack on a passing merchant ship. After successfully defending themselves, the merchants made their way ashore, whereupon their leader "drank water from the land" and married the woman ruler, who is described as the daughter of the ruler of the Realm of Water. Water eases the transitions between the inside and the outside.

Water (III) / Ambivalence toward water is an instance of a "double coding" of nature, which is in turn related to a "dialectic of visibility/opacity"—the will to enclose or expose environmental phenomena (for example, a concealed culvert versus an exposed waterway).[112]

112. On "double coding" of nature, see Maria Kaika and Erik Swyngedouw, "The Environment of the City ... or the Urbanization of Nature" in A Companion to the City, ed. Gary Bridge and Sophie Watson (Malden, MA: Blackwell Publishing, 2000), 572. On the "dialectic of visibility/ opacity," see Maria Kaika and Erik Swyngedouw, "Fetishizing the Modern City: The Phantasmagoria of Urban Technological Networks," International Journal of Urban and Regional Research 24, vol. 1 (2000): 122.

Water (IV) / As water becomes commodified and fetishized, "nature itself becomes re-invented in its urban form (aesthetic, moral, cultural codings of hygiene, purity, cleanliness, etc.) and severed from the grey, 'muddy,' kaleidoscopic meanings and uses of

water as a mere use-value. Burying the flow of water via subterranean and often distant pinpointed technological mediations (dams, purification plants, pumping stations) facilitates and contributes to masking the social relations through which the metabolic urbanization of water takes place. The veiled subterranean networking of water facilitates severing the intimate bond between use value, exchange value, and social power."[113]

113. Kaika and Swyngedouw, "Fetishizing the Modern City," 121.

Water Clock / Su Song, who had in 1088 assembled a hydro-mechanical astronomical clock tower in Kaifeng, China, wrote: "There have been many systems and designs for astronomical instruments during past dynasties differing from one another in minor respects. But the principle of the use of water power for the driving mechanism has always been the same. The heavens move without ceasing but so does water flow [and fall]. Thus if the water is made to pour with perfect evenness, then the comparison of the rotary movements [of the heavens and the machine] will show no discrepancy or contradiction; for the unresting follows the unceasing."[114] This hydraulic line of horological development ceased with the gradual perfection of the European mechanical clock, where the measure of time is no longer dependent on elemental forces, like water, nor connected to the movement of celestial bodies.[115]

114. Joseph Needham, Science and Civilisation in China, vol. 4, Physics and Physical Technology (Cambridge: Cambridge University Press, 1971), 545.

115. Landes, Revolution in Time.

Water Engineering / The earliest "water engineering" efforts in

Singapore, beginning from its days as a colonial settlement to the first decades of independence, can be described as an instance of a disciplinary mechanism based on the notions of containment and separation. Marshes were drained, waterways were concretized; the canal network was expanded and stormwater was to be immediately conveyed to the sea and reservoirs. Water was perceived as something that must be kept out of sight and out of reach. By the early 2000s, it was clear that there was a sea change in the Singaporean state's engagement with water. The older model was deemed as "detrimental to water quality, ecosystems, mosquito control, the aesthetic character of [the] landscape and the affective bond between citizens and water. Property prices were also adversely affected, producing a discrepancy which of course the URA [Urban Redevelopment Authority, Singapore] was keen to amend."[116] The infrastructural logic of concealment and containment was to be "inverted." Newer urban planning notions such as deculverting no longer regard water "as a nuisance to be expelled but as a valuable resource to be accommodated and treated through natural filtration, thereby increasing retention time and prolonging the presence of water in the city."[117]

116. Usher, "Government of Water, Circulation and the City," 188.

117. Usher, "Government of Water, Circulation and the City," 43.

Waterfront / Waterfront design "would seek to incorporate footpaths and bridges where possible to allow 'people to get close to, and enjoy, the water.' [...] To assist this transition, statutory requirements relating to land use would be relaxed to encourage development of what were considered 'compatible water-side activities.' Indicative of this neoliberal style of relational government, the [Water Design] panel deduced that 'treatment of the water's edge determines the sort of relationship that can be established between the landscape and the water.' [...] The edge condition was a site of much calculation and deliberation for the panel; how the spatial continuum between the terrestrial and aquatic affects the ambience of a waterfront and the behaviour of visitors."[118] "The waterfront would eventually become a domain of meticulous calculation and what John Allen terms 'ambient power,' a poly-functional site of strategic significance, where naturalisation projects reconfigured the edge condition and conduct of the population."[119]

118. Usher, "Government of Water, Circulation and the City," 133.

119. Usher, "Government of Water, Circulation and the City," 216.

Water Wheel / Minang, Negeri Sembilan Malay: *kinchir ayer*. Water wheels made out of bamboo tubes were an important agricultural technology devised by the people of the Minangkabau highlands of West Sumatra to water their extensive terraces and fields of paddy. The historian Richard James Wilkinson explains their operation as follows: "The wheel has paddles (*iroh kinchir*); the pressure of a stream against these paddles makes the wheel revolve; and, as it revolves, it raises bamboo cylinders (*tabong kinchir*) filled with water to its own highest point. As each tabong reaches the apex and begins to descend its contents are automatically

emptied out into a conduit that carries the water into the fields. In this way water is raised from the stream to the higher level of the fields round it."[120]

120. Faris Joraimi. R. J. Wilkinson, *A Malay-English Dictionary* (Singapore: Kelly & Walsh, 1902), see http://sealang.net/malay/dictionary.htm.

Wetland / Mangroves are known for their morphological adaptation to wetland environments—areas of marsh and water—as well as their ability to survive in conditions such as muddy soil and coral rock, and in water with saline levels up to a hundred times higher than what most other plants can tolerate. Able to withstand the brunt of flooding, ocean-borne storms, and hurricanes, mangroves are a restorative, protective presence, providing some shelter against the destructive force of natural disasters like hurricanes and tsunamis, further absorbing pollutants and improving soil chemistry.[121]

121. By Johann Yamin.

When / The question is not so much "What is an infrastructure?" as "When is an infrastructure?"[122]

122. Geoffrey C. Bowker, "Sustainable Knowledge Infrastructures" in *The Promise of Infrastructure*, 2014.

Work-In-Progress / "Infrastructure today seems both an all-encompassing solution and an omnipresent problem, indispensable yet unsatisfactory, always already there yet always an unfinished work in progress."[123]

123. Rutherford, *Redeploying Urban Infrastructure*, 10.

Y / Symbol to indicate measurement of humidity.

Zoning / Liquid modernity is still dependent on the construction of zonal containers, even if these containers may be subjected to change over time. However, we should remember that zonal

technologies include not just the construction of special economic zones, but also that of time zones calibrated for logistical flows.

ALL WOMEN ARE WORKERS, NOT ALL WORK IS WAGED: THREE TALES OF SURVIVING THE PANDEMIC IN PUDUCHERRY

MEENA KANDASAMY

December 2020

In the village of Vadhanur, southeast India, Poorani wakes up with the sun around five every morning. She sweeps her home and takes a bath, then steps outside to draw the customary *kolam* on the ground. A geometric floral drawing made of powdered stone, kolam is a Tamil woman's tradition of everyday art intended to welcome guests and believed to be auspicious. Poorani's designs are elaborate, expansive, filled with colorful powder on festival days, but on an ordinary morning she is content to make an express edition: a matrix of dots and stars and quick, snaking lines.

She then visits the little shed beside her home, where she milks her two cows and carries the milk to the homes of those who buy it from her. At seven, she leaves for work at the fields about a kilometer away. Some days, she takes along the cows, letting them graze on common grounds.

Vadhanur is an agricultural village, filled with fields of rice paddy, sugarcane, and cassava. It is an hour's drive from the coastal city of Puducherry, known to most Indians as a tourist hotspot and erstwhile French colonial settlement.

Poorani is a coolie, paid in daily wages for working the fields in Vadhanur. The nature of her work changes depending on the seasonal vagaries of farming. Listening to her reel off all that she can do, I feel that there is little she cannot do. She speaks to me of her expertise in transplanting paddy rice. Some days, at the end of a paddy season, her work involves the labor-intensive job of harvesting. Then there are the tasks of weeding or clearing the fields. She helps to maintain the complex irrigation and drainage channels that are required to

water the paddy. When she has finished describing her work, she pauses, looks at me with a disarming smile, and asks, "So, what is it that you want to know?"

Confronted in this manner, I'm momentarily at a loss. Poorani is tall, dark, and strikingly beautiful. She wears a large, gold nose ring; in comparison, my tiny dot of a nose pin feels almost like an apology. She exudes silent strength and confidence. Her looks defy her advanced age: her black hair, which she wears in a low bun, has only the tiniest touch of silver.

While her work is crucial to farming, she is at the bottom of the hierarchy. Not a homogeneous category by any means, India's farmers include a minority of land-holding cultivators supported by a majority of mostly landless agricultural workers. Caste, which dictates every aspect of Indian life, is shamefully persistent here. Poorani is Paraiyar, one of India's Dalit (formerly untouchable) castes. Like seventy percent of Dalits who are involved in farming, she is landless, having worked for daily wages in other people's farms all her life.

Poorani has been working in the fields since she was fifteen years old. "I was never sent to school; I do not even know the alphabet. My parents were also agricultural coolies. They married me away when I was very young, only ten years old, even before I came of age."

She is uncertain of her age. "I must be about fifty-five. For the last forty years I have been working, working. I learnt everything I know by watching my parents work. I must have been as young as ten. No one taught me anything. I can do every sort of work there is. Now I am limited by age, so I do not go to do winnowing. After my husband died, about six years ago, I could not go and work in the sugarcane fields. Men cut the sugarcane, women fetch food from home and tie up the sugarcane in bundles. They employ people as couples mostly, so without my husband, I don't get that job."

For Poorani, a typical day in the fields involves working from 7 a.m. to noon, followed by a short break for a lunch of rice and curry. Some afternoons, she uses this precious break time to graze her cows. She returns to the fields in the afternoon, where she works until sunset. This has been her routine for many decades.

"Where do you fit in the time to make food?" I ask, studying her kitchen with its red gas cylinder and stove, stainless steel utensils, plastic spice jars, and tiny sink in the corner. She laughs away my question. "For the last three years I have not even entered the kitchen. Even if I try to wash a single utensil, my daughter-in-law forbids me: 'Amma, you should not do it.'"

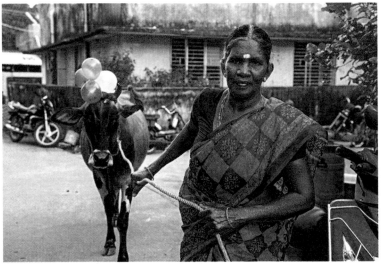

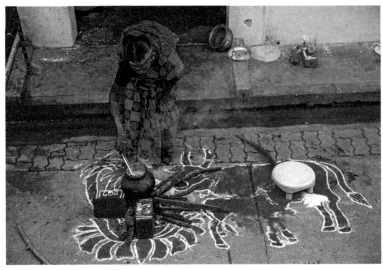

1. Poorani celebrating Mattu Pongal, the day when cattle that assist with plowing the fields and other aspects of daily life are celebrated. Mattu Pongal is a four-day-long harvest festival celebrated mostly in the states of South India, especially in Tamil Nadu. Photograph by Pattabi Raman.

2. Poorani preparing a traditional Pongal in front of her house. *Pongal* means boil or overflow, and refers to the traditional dish prepared from the harvest of new rice boiled in milk with jaggery. Photograph by Pattabi Raman.

3. Poorani and other women working in the field in Vadhanur village, Tamil Nadu. Photograph by Pattabi Raman.

4. Poorani posing with goats in the field at Vadhanur village, Tamil Nadu. Photograph by Pattabi Raman.

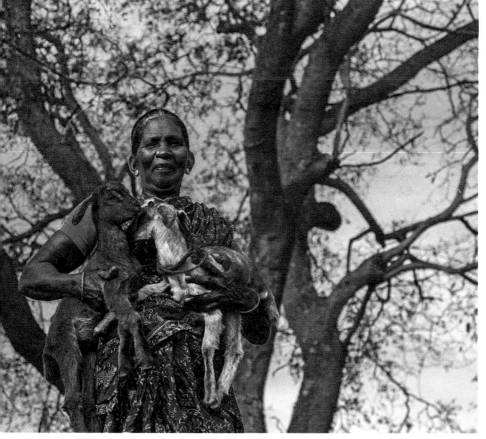

The head of her household, she lives with her son Rajesh and daughter-in-law Nadiya, and her youngest daughter, Poonkodi, who is in college. Another daughter, Rajakumari, lives in the same village with her husband and two little girls. "Before my daughter-in-law came to live with us, I was the one who used to cook. I'd make something quick and easy: lemon rice, tomato rice, anything my daughter could pack for lunch before going to college. I never had time, so I would cook in a hurry," Poorani says.

When talk turns to the daughter-in-law, Poorani's nephew, Sivachandran, who is hanging around, makes a point of interjecting: "She is from another caste."

"When my son first said he was in love, I was cautious," Poorani says. "I said, we are different castes, who will speak up on our behalf?"

Puducherry, like neighboring northern Tamil Nadu, has witnessed increasing violence by dominant-caste Vanniyars against Dalits. Hate propaganda claiming that Paraiyar men, like Poorani's son, are luring Vanniyar women into marriages has intensified. This has made Dalit men targets of violence, and subjected women to greater patriarchal control.

"It has been three years; no one from her family ever visits. We took care of all her wedding expenses," Poorani says. "Luckily, there hasn't been any problem."

Undaunted and defiant in conducting an intercaste marriage, she has not been held back by her poverty, her widowhood, or her social position in asserting her leadership. "Many women come and work on the fields. I am in charge, I take them along with me, make sure they do the work for the day. Vanniyar women come and work with us too—where we work there are no problems."

It was Poorani's work in the fields and the milk from her cows that kept her family afloat in the darkest days of the first COVID lockdown that lasted from late March until late June 2020. She wears her enormous responsibility lightly, and with unstated humility. I ask if the lockdown had any effect on her day-to-day employment, or caused any reduction in her wages. "Corona or no corona is the same for me," she says. "Even during corona, we kept going to work in the fields all the time. I was never home, never out of work. We never considered corona a problem. No one I knew got the disease."

"My income was not affected because of corona. You see, I earn a daily wage, I'm a coolie—how will they reduce my wage? If I dig a canal, I'm paid Rs. 150 (USD $2) a day. If I go to transplant paddy, I'm paid Rs. 120 (USD $1.50) a day. If it is a job that requires 20 people, and then 10 people don't turn up, I'd

earn more, I might get around Rs. 200 (USD $2.60) a day."

Others in her family have had to endure the immediate fallout of the lockdown. "My son didn't have a job for months. He works as a driver at a private company. They asked him to go on leave, and they did not pay him any salary. We tried our best not to take any loans, we cut all costs where possible, we lived our most frugal life."

Poorani adds, "Neither my daughters nor my daughter-in-law knows any agricultural work, so at a time like this I support the whole family."

I am curious to know what she does when she is not working. "I take care of my grandchildren, the little girls, on some evenings," she says. "Then, I'm enjoying this serial called *Bharathi Kannamma* on Vijay TV. I have watched it right from the first episode." She gives me a short summary of the series in which a daughter-in-law faces all kinds of hardship, a protective mother-in-law on her side.

The intense physical work for forty years or more has taken its toll, but Poorani brushes aside any questions about her health. "There are times when I feel sore and my body aches. But I am afraid of injections, medicines—so I do not go to the hospital. I only went there for the birth of my three children. When I am in pain, I do not tell my family."

March 2021

I meet Divya in Puducherry; she turns up when I advertise for a babysitter.

I am a sleep-deprived mother of two toddlers in a new town; I have been single parenting for five months while their father is away in London. Precarity as a freelancer in the gig economy and the aggravated isolation in the pandemic are the reasons why I fled the UK, taking the children with me. Five editions of my books were coming out in 2020, but I had no launches, no travel, no events, no money. I did not know where the next week's groceries were coming from. I spent sleepless nights over the injustice of being able to afford to put only one of my children in a nursery.

India is easier on the pocket, but there are no schools or nurseries open here, and without a partner who will shoulder some of the childcare my life has become nightmarish. I have not been able to find the time to shower in days. I wake up at 6 a.m. with the kids and after they are asleep I work until 2 a.m., trying to make money that will pay the bills. I am alarmed at my condition because now I have started falling asleep while I read books to the little ones in broad daylight. I need help before it is too late because I end up endangering the lives of my kids.

Divya is a qualified nurse who has found herself suddenly out of a job and looking for a new one. She was on COVID duty during the first wave of the pandemic, working eighteen-hour shifts in a PPE. When the cases began to decrease, and eventually taper out, in late 2020, the hospitals sent her home. The only money that comes her way now is from home visits to change dressings, administer injections, or stay overnight as a caretaker for a very ill patient. That money is not enough to run a household. Divya's mother, who raised her children alone, works as an attendant in the hospital on a paltry, poverty-level wage, which she cannot bring herself to share. Her younger sister is affected by autoimmune illnesses; she cannot venture outside for a job and her medical expenses are well beyond the meager wages of any available jobs.

Divya and I are good fits for each other's desperate situations. My children love her. I do not begrudge that love, do not feel the least bit jealous or possessive. I welcome her arrival every evening as that of a savior. Ah, some rest. Ah, a shower. Ah, three hours of writing time. Ah, grocery shopping. I've never been more thankful for anyone's presence.

When we reach a comfort level great enough to discuss caste locations, she points to the photo of the Dalit leader B. R. Ambedkar that I keep in my workspace and asks if I can recommend any books to read on his struggle. Dee was born to an intercaste couple—from Dalit and Vanniyar castes—and we relate to each other's hybridity, our non-location location.

Because lockdown orders have not been lifted, she is also the only adult I meet daily. We talk about finding a good tailor to stitch sari blouses for me. She gives me her Instagram handle, we follow each other.

All this camaraderie does not last forever.

A month later she tells me that infections are increasing again, and she has been asked to resume her job as a nurse on COVID duty. She will be conducting the RT-PCR swab tests at a COVID center.

I do not want to hide this from you, she says. I need the salary but my conscience does not let me continue working here. I am afraid of combining that job with this—I have seen small children suffer and it is the saddest thing in the world.

While the cruel second wave consumes lives, Divya continues to work full time as a nurse on COVID duty. Once again, it is a life of PPE kits and eighteen-hour shifts. She has not slept in days. My children ask me to make her come and visit them. I do not have the heart to tell them that it will be a while before they see her again.

March 2021

As the virus receded, we imagined that life would return to some semblance of normality. That we would no longer have to contend with this inversion of reality we were inhabiting: The deserted streets of White Town. Rock Beach empty on weekend mornings. Instagram-worthy graffiti tags appearing gloomy in their loneliness. Local creperies and patisseries closed indefinitely.

My partner has not yet joined me. We are not married, so legally we have no claims to visit each other.

The silence of the pandemic is replaced by the silence of state oppression. Political chaos led to the lieutenant governor of Puducherry flexing her power and calling in the paramilitary. Riot-control vehicles, concertina wire, water cannons. Armed men in blue camouflage walk around with guns in their holsters, or an AK-47 slung over their shoulders. We have not fully transitioned out of lockdown, but for weeks we have resembled a state of siege, of occupation. The government is toppled, the elections take place, a new government is sworn in, a new lockdown is instated. Somewhere in the backdrop of this political drama on a tiny Union Territory, the second wave strikes, peaks, abates.

Lives that were destabilized during the pandemic's first wave are now being ravaged.

All of us deserve our own stories; who can take solace in becoming a statistic?

Under a strict lockdown, it is difficult to find the people who will share their stories. On the streets, it is possible to believe that we are frozen in time—a ghost town abandoned by war or flooding or plague. Beaches remain under curfew orders; I sneak in with my children one morning and find no other people. We see fishermen out in the distance on tiny rowboats; a mongoose runs along the dark rocks, startling us; my younger son says he has seen a big blue whale. Imaginations run riot.

A friend of mine who works at the front desk of a four-star heritage hotel in the city has his salary halved, his monthly workdays reduced to ten. The tourism industry is doomed— for nights on end there are no bookings.

Auto rickshaw drivers say that on many days of the week there are no rides, there is no money.

Everyone is asked to work from home, and so many maintenance jobs disappear. A woman who cleaned offices now hunts for a job as a domestic worker. Horrific videos have surfaced, such as rich and the middle-class employers dousing domestic workers in disinfectant spray as if they were insects.

Electricians who worked round the clock in three shifts now subsist on two shifts and take two days off per week.

My landlord says he cannot find a plumber so he repairs my kitchen sink with scotch tape and bubblegum. Two days later, his handiwork gives way and it raises a stink. My four-year-old child suggests I try using Play-Doh instead.

A photographer friend has had only one paid assignment in an entire year. He is lucky to be living with his parents.

Postgraduates with an MBA in Human Resources are content doing data-entry jobs. Owners of mobile phone repair shops start selling vegetables outside their premises in order to pay their staff.

I meet a Swiggy food-delivery driver, a man in his mid-forties, who was a manager before the business folded.

A political worker laments that he is not able to engage actively in politics; likewise, schools are shut down, his wife no longer has a teaching job. If she had her income, he could afford to do grassroots work. Now his only option to make ends meet is to drive a taxi—except that one cannot drive anywhere now. Night curfews are in place. Every highway has manned check posts, and one has to furnish an electronic permit and proof of the necessity for urgent travel in order to be allowed to drive further. Good never comes when radical political work is stymied: rapes rise, murders rise, caste-related atrocities rise, child abuse rises—and no one is allowed to go out into the streets to demand justice.

Statistics reveal that unemployment in Puducherry stands at 47.1 percent, against the national average of 9.2 percent in June 2021. During the first wave, unemployment rates reached 75.8 percent, an absolute shock to the system. The tourism crash has had a domino effect. For a city with a population of just over a million, these numbers bespeak decades of abject governmental neglect.

People here are so scared of the virus that they stop going to hospitals, even to treat other illnesses. Every week, at least two ornate funeral processions come down our street. I tell my children what death is, what it means to grow old, to grow sick and die. It means that someone is gone forever and will never come back. Papa is coming back, they clarify. Yes, I tell them. He is. They come out onto the balcony and watch every funeral. They hate the loud crackers; covering their ears, they come and huddle in my arms. They are fascinated by the drums and the flower garlands.

They already know a lot about the coronavirus. My little son opens a Duplo brand hippo's mouth, inserts my index finger,

and mimics the endless checking with the oximeter. Instead of school lessons, this is what he is learning these days. Still, he is one of the luckier ones.

Elsewhere around me children are dropping out of school at alarming rates. Most of them end up working alongside their parents. I see a ten-year-old boy walk to a field with his mother, carrying a spade over his shoulder. His mother tells me it is safer to take him with her than to leave him unattended at home.

I think of Poorani's story, of her stolen childhood. None of this should be happening.

Like everyone else, I wish all this would end.

(Some names have been changed or withheld to protect identities.)

AUTHOR BIOGRAPHIES

After completing her MA in English Literature from Jadavpur University, **Trina Nileena Banerjee** proceeded to complete a Masters of Studies (M St.) in English at the University of Oxford. She is currently Assistant Professor in Cultural Studies at the Centre for Studies in Social Sciences Calcutta. Her research interests include gender, performance, political theater, theories of the body, postcolonial theater and South Asian history. She has also been a theatre and film actress, as well as a journalist and fiction writer. Her book *Performing Silence: Women in the Group Theatre Movement in Bengal* was published by Oxford University Press (India) in November 2021.

Leticia Bernaus is an Argentinian visual artist working with moving image, photography, performance, installation, and writing. Her work is a subtly provocative investigation of the contemporary link between the natural and the cultural. Bernaus superimposes materials and formats, dissolving the borders between animal and mineral, immaterial and physical, documentary and fiction. Her work has been exhibited in the United States, Italy, England, Spain, Argentina, Brazil, Australia, and Canada. Bernaus received her Masters of Fine Arts from the University of Illinois at Chicago in 2019. She has been awarded the UIC University Fellowship (2017–2019), the IILA – Fotografia 2017 Prize and residency in Rome (2017, 2018), the Illinois Arts Council Awards (2020), and the Chicago Artists Coalition BOLT residency (2019–2020). She lives and works between Villa María, Argentina, and Chicago, United States.

Amitesh Grover is an award-winning director and artist. He moves beyond theater into installation, text, photography, and performance. His work delves into themes like the dyad of absence/presence, the necessity of remembering, and the performance of resistance to keep on living. He is the recipient of the MASH FICA New Media Award, Swiss Art Residency Award, Bismillah Khan National Award, Charles Wallace Award (UK), and was nominated for the Arte Laguna Prize (Italy), Prix Ars Electronica (Austria), and Forecast Award (Germany). His work has been shown globally at venues like the Southbank

Centre (London), Arts Centre (Melbourne), MT Space (Canada), HKW (Berlin), Belluard Bollwerk International (Switzerland), Hartell Gallery (US). In India, he has shown at the Foundation of Indian Contemporary Art, Kiran Nadar Museum of Art, Chennai Photo Biennale, VAICA Video Art Festival, Prithivi Festival, among several others. He has curated the ITFoK Festival (Kerala), Ranga Shankara (Bangalore), and Nove Writers' Festival (Prague). He studied at University of the Arts London, and is a published author in several performance journals. Currently, he is Associate Professor at the National School of Drama, and is based in New Delhi, India.

Uzodinma Iweala is an award winning writer, filmmaker, and medical doctor. As the CEO of The Africa Center, he is dedicated to promoting a new narrative about Africa and its diaspora. Uzodinma was the CEO, Editor-In-Chief, and co-Founder of *Ventures Africa* magazine, a publication that covers the evolving business, policy, culture, and innovation spaces in Africa. His books include *Beasts of No Nation*, a novel released in 2005 to critical acclaim and adapted into a major motion picture; *Our Kind of People*, a nonfiction account of HIV/AIDS in Nigeria released in 2012; and *Speak No Evil* (2018), a novel about a queer first-generation Nigerian-American teen living in Washington, DC A graduate of Harvard University and the Columbia University College of Physicians and Surgeons and a Fellow of The Radcliffe Institute at Harvard University, he lives in Brooklyn, New York.

Patrick Jagoda is Professor of Cinema & Media Studies, English, and Obstetrics & Gynecology at the University of Chicago. He is Executive Editor of *Critical Inquiry* and director of the Weston Game Lab. Patrick's books include *Network Aesthetics* (2016), *The Game Worlds of Jason Rohrer* (2016, with Michael Maizels), *Experimental Games: Critique, Play, and Design in the Age of Gamification* (2020), and *Transmedia Stories: Narrative Methods for Public Health and Social Justice* (2022, with Ireashia Bennett and Ashlyn Sparrow). He designs transmedia, digital, and analog games. He is a recipient of a 2020 Guggenheim Fellowship.

Meena Kandasamy is an anti-caste activist, poet, novelist, and translator. She has always been interested in deconstructing violence, understanding the trauma caused by caste, gender, and ethnic oppressions, and spotlighting the militant resistance against these powerful systems. She explores these topics in her poetry and prose, most notably in her books of poems such as *Touch* (2006) and *Ms. Militancy* (2010), as well as her three novels, *The Gypsy Goddess* (2014), *When I Hit You* (2017), and *Exquisite Cadavers* (2019). Her novels have been shortlisted for the Women's Prize for Fiction, the International Dylan Thomas Prize, the Jhalak Prize, and the Hindu Lit Prize. Her op-eds and essays have appeared in *The White Review, Guernica, The Guardian* and *The New York Times*.

Siyanda Mohutsiwa is a noted satirist from Botswana, and a graduate of the Iowa Writers' Workshop, where she studied under Sam Chang, Ayanna Mathis, and Ethan Canin. Her writing has appeared in *Tin House Magazine, The Bare Life Review, Lolwe*, and other literary journals. Siyanda's fiction has also been featured in numerous anthologies and in 2019 she was shortlisted for the Morland Prize. She's also a prominent speaker, whose talks about humor, pan-Africanism and the internet have led her to give keynote addresses around the world, in the company of world leaders and policy makers. Her most famous talk was delivered at the TED conference in 2016. She is pursuing a doctorate in Sociology at the University of Chicago, where she's a member of the Knowledge Lab, and the president and founder of the BLTR social club for Black Women in Doctoral programs.

Ho Tzu Nyen makes films, installations, and performances that often begin as engagements with historical and theoretical texts. His recent works are populated by metamorphic figures such as the weretiger (*One or everal Tigers*, 2017) and the triple agent (*The Nameless*, 2015), under the rubric of *The Critical Dictionary of Southeast Asia*, an ongoing meta project. Solo exhibitions of his work have been held at Hammer Museum at UCLA (Los Angeles, USA, 2022), Toyota Municipal Museum of Art (Toyota City, Japan, 2021), Crow Museum (Dallas, USA, 2021), Yamaguchi Center for Arts and Media (Yamaguchi, Japan, 2021), Edith-Russ-Haus for Media Art (Oldenburg, Germany, 2019), Kunstverein in Hamburg (Germany, 2018), and Ming Contemporary Art Museum (Shanghai, China, 2018).

Ashlyn Sparrow is the Assistant Director of the Weston Game Lab (WGL) and an independent game designer. Her work focuses on creating socially impactful games and health-focused app interventions. Through @westongamelab she has developed a series of alternate reality games including Indiecade award-winning game *Terrarium*, *A Labyrinth*, and *Echo*. In addition to her work at WGL, she is a game designer and programmer in Chicago, having worked on *Oni Fighter Yasuke* for Waking Oni Games.

Jeet Thayil was born into a Syrian Christian family in Kerala. As a boy he traveled through much of the Indian subcontinent, Southeast Asia, and North America with his father, T.J.S. George, a writer and editor. He worked as a journalist for twenty-one years, in Bombay, Bangalore, Hong Kong, and New York City. In 2005 he began to write fiction. The first installment of his Bombay Trilogy, *Narcopolis*, was shortlisted for the Booker Prize and became an unlikely bestseller. His book of poems *These Errors Are Correct* won the Sahitya Akademi Award (India's National Academy of Letters), and his musical collaborations include the opera *Babur in London*. His essays, poetry and short fiction have appeared in the *New York Review of Books*, *Granta*, *TLS*, *Esquire*, *The London Magazine*, *The Guardian*, and *The Paris Review*, among other venues. Jeet Thayil is the editor of *The Penguin Book of Indian Poets*.

Suraj Yengde is one of India's leading scholars and public intellectuals. Named as one of the "25 Most Influential Young Indians" by *GQ* magazine and the "Most influential Young Dalit" by *Zee*, Suraj is an author of the bestseller *Caste Matters* and co-editor of the award-winning anthology *The Radical in Ambedkar*. *Caste Matters* is being translated in seven languages. Suraj was a Senior Fellow at the Harvard Kennedy School. He holds a research associate position with the department of African and African American Studies, a non-resident fellow at the Hutchins Center for African and African American Research, and is part of the founding team of Initiative for Institutional Anti-Racism and Accountability (IARA) at Harvard University. He has studied in four continents, and is India's first Dalit PhD holder from an African university (University of the Witwatersrand, Johannesburg). He is currently pursuing a second doctorate at the University of Oxford.

EDITOR BIOGRAPHIES

Orianna Cacchione is Curator of Global Contemporary Art at the Smart Museum of Art, The University of Chicago. Her curatorial practice is committed to decolonizing the canon of contemporary art to better reflect the global circulation of art and ideas. She recently opened *Monochrome Multitudes*, an exhibition that reconsiders the "monochrome" materially, conceptually, and globally and is currently developing another major project to recognize Transpacific artistic exchanges. Recent exhibitions include solo presentations of Tang Chang, Samson Young, Zhang Peili, and Bob Thompson, and the thematic exhibition, *The Allure of Matter: Material Art from China*. Cacchione holds a PhD in Art History, Theory and Criticism from the University of California, San Diego. Her scholarly research explores the transnational, cross-geographic flows of art and art history that characterize the global art world. Her writing has been published in *Les Cahiers du musée national d'art moderne, The Journal of Art Historiography, Yishu*, and the *Journal of Contemporary Chinese Art.*

Nandita Jaishankar has worked as an editor in New Delhi, India, since 2003. She has also worked on the *Lalit Kala Contemporary Journal* (Vol 52), a special issue dedicated to photography, titled *Depth of Field: Photography as Art Practice in India* (2012) and *From Kabul to Kolkata: Of Belonging, Memories and Identity*, a catalogue for an exhibition of the same name showcased in Kabul, New Delhi, and Kolkata (2015). Her poems have been featured in an anthology of poetry, *Writing Love* (Rupa & Co), published in 2010, as well as the fall issue of *Pyrta: A Journal of Poetry and Things, Asia Writes* and *Ceriph*. In 2011, along with Rahaab Allana, she co-founded *PIX*, a publication that looks at contemporary photography and writing around photography in South Asia. She is currently Senior Manager, Editorial & Programmes, Serendipity Arts Foundation, for which the largest outreach is Serendipity Arts Festival, one of the largest multidisciplinary platforms for the arts in South Asia.

Arushi Vats is a curator and writer based in New Delhi, India. Her essays have been published in online and print platforms such as *Usawa Literary Magazine*, *Art India Magazine*, *Runway Journal*, *Alternative South Asia Photography*, *LSE International History*, *Critical Collective*, *Write | Art | Connect*, *Frontline*, *Scroll*, *Mint*, and *The Quint*, and in catalogues and anthologies by Serendipity Arts Foundation, New Delhi; Museum of Art and Photography, Bangalore; *Global Visual Handbook of Anti-Authoritarian Counterstrategies* published by The Rosa Luxemburg Stiftung (forthcoming, 2023); and Safdar Hashmi Memorial Trust, India. She is the associate editor for Fiction at Alternative South Asia Photography, and the recipient of the Momus - Eyebeam Critical Writing Fellowship 2021, and the Art Scribes Award 2021. She has attended residencies at La Napoule Art Foundation, France (2022) and the digital Momus Emerging Critics Residency (2021).

ABOUT THE INSTITUTIONS

Serendipity Arts Foundation is an organization that facilitates pluralistic cultural expressions, sparking conversations around the arts across the South Asian region. Committed to innovation and creativity, the aim of the Foundation is to support practice and research in the arts, as well as to promote sustainability and education in the field through a range of cultural and collaborative initiatives. The Foundation hosts projects through the year, which include institutional partnerships with artists and art organizations, educational initiatives, grants and outreach programmes across India.

As the fine arts museum of the University of Chicago, the **Smart Museum of Art** is a site for rigorous inquiry and exchange that encourages the examination of complex issues through the lens of art objects and artistic practice. Through strong scholarly and community collaborations and a welcoming approach to its exhibitions, collections, publications, research and teaching, and public programs, the Smart Museum plays a dynamic role in expanding artistic canons, rethinking received histories, introducing new perspectives, and engaging diverse communities—locally, nationally, and internationally. The Smart Museum will celebrate its 50th anniversary in 2024.